H.N. Werkman

MONOGRAPHICS

H.N. Werkman

Alston W. Purvis

Yale University Press

Published in North America by
Yale University Press
P.O. Box 2009040
New Haven, CT 6520-9040

First published in Great Britain in 2004 by
Laurence King Publishing Ltd, London

Library of Congress Control Number:
2004107064

ISBN 0-300-10290-9

Designed by Brad Yendle,
Design Typography, London
Series editor: Rick Poynor

Printed in China

Frontispiece: detail of December page
of *Kalender 1944* (1944 Calendar), 1943,
32 × 24.5 cm (12$\frac{1}{2}$ × 9$\frac{5}{8}$ in).

This book is dedicated to Jan Martinet,
the quintessential Werkman scholar.

Contents

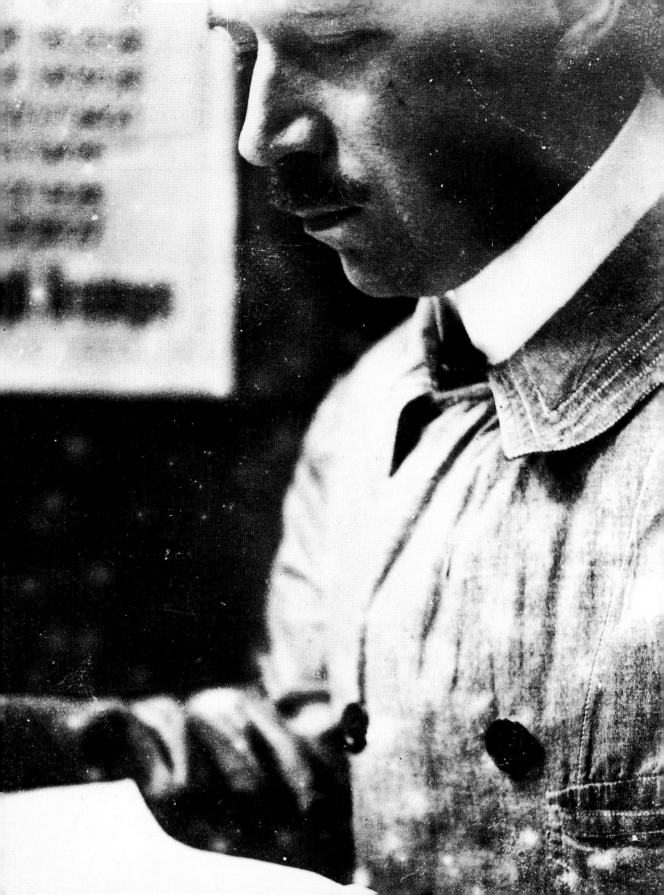

Struggling is not Useless

H.N. Werkman, c. 1920.

Hendrik Nicolaas Werkman helped to free letterforms from their traditional functions and by the time of his death in 1945 had substantially reinterpreted their artistic and symbolic significance. The simple application of human, non-conformist and unrestrained elements in his printed work forms the basis of his importance as an artist. Although Werkman was also a painter, he had no training in painting and resorted to what he knew best, the printing press. Few in number, his paintings are sombre and heavily influenced by Vincent van Gogh, Ernst Ludwig Kirchner and Edvard Munch, all of whom shared Werkman's propensity for melancholy.

Werkman believed that the hidden paths are the most beautiful ones. Playful innocence, a resplendent vitality and the element of surprise characterize his creations. His legacy is to teach us that type can function independently without needing to communicate a message and that graphic design need not be bound to the new technology of its time (in Werkman's case offset printing and photography). He showed that it is possible for graphic design to come from the heart and amount to more than craftsmanship; that it does not have to rely on systems, modes or rules; and that the human touch in design is still vital. In the end, his work seems to say, the transcendental can prevail.

Werkman was a controversial figure among his Dutch avant-garde contemporaries (the Constructivists and those associated with De Stijl), and even today many traditional designers view his work with scepticism. Willem Sandberg, graphic designer and director of the Stedelijk Museum in Amsterdam after World War II, was one of his first supporters and as early as 1960, prominent US graphic designer Paul Rand recognized Werkman as a heroic figure who shared his own enchantment with the play instinct in graphic design. (Among Rand's treasures was a copy of *Hommage à Werkman* by H.A.P. Grieshaber published in Stuttgart and New York in 1957 and 1958 respectively.)

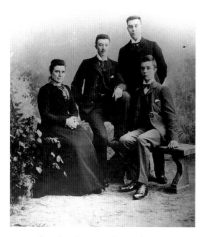

A 1902 family photograph: Werkman's mother, Grietien Alingh Louwes Werkman; H.N. Werkman; brothers Pieter Jacob Werkman and Martinus Hendrik Werkman.

In spite of having some advocates, however, Werkman founded no school and had no direct followers. In graphic design history he has usually been depicted as a minor player and art history in general ignores him. Because of the individual nature of his work and because he never aligned himself to any particular movement, Werkman will never fit comfortably into a compartment of graphic design history. In *A History of Graphic Design*, Philip B. Meggs included him in the chapter titled "The Bauhaus and the New Typography" for want of a more appropriate category. One of my former colleagues at the Royal Academy of Fine Arts at The Hague expressed both surprise and dismay that I devoted an entire chapter to Werkman in a book about Dutch graphic design.[1] Yet since my first encounter with Werkman's art in the early 1970s, it was clear that this was someone who had been inexplicably overlooked – perhaps one of the most neglected figures in 20th-century graphic design.

Werkman was a solitary figure, described by Herbert Spencer, author of *Pioneers of Modern Typography*, as "honest, simple, contemplative yet passionate – and above all, intensely human".[2] Never attracted by the "pack mentality", as an outsider he is and will remain to some extent an enigma and that is part of his enchanting appeal. His distinctive, idiosyncratic vision is at odds with the uncompromising and functional stance of the Constructivists, who, as the Dutch designer Paul Schuitema reflected in 1961, contended that "a letter was to serve the function of reading, nothing else".[3]

While maintaining a number of largely detached, international contacts, Werkman was essentially a loner, for the most part cloistered in his attic studio tenaciously creating on his letterpress. Trips away from home were rare and self-promotion was never part of his character. Werkman had few close friends and, until his later years, few correspondents. In August 1943, he wrote to the man who would become his closest friend and confidant, the Reformed Minister F.R. August Henkels: "… in my heart I am a loner who occasionally feels the need of some companionship".[4] Werkman was shunned by certain colleagues in De Ploeg (The Plough), the art circle to which he belonged, and with the exception of his youngest daughter Fie and oldest son Hendrik, even his family showed little enthusiasm for his chosen form of art.

Werkman was born the second of three sons on 29 April 1882 in Leens, a small town in the Northern Dutch province of Groningen.

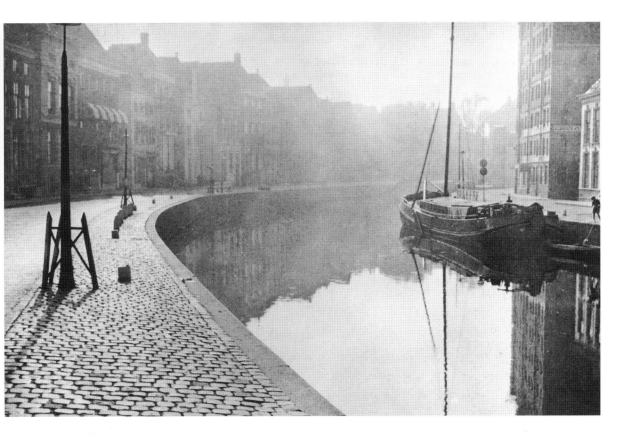

Lage der A, Groningen, c. 1926. Photograph: J. Kooy.

Werkman's business card, c. 1901, printed with the words "Amateur-Fotograaf Groningen" (Amateur Photographer Groningen).

His veterinarian father died as the result of an accident in the autumn of 1891 and four years later his mother moved with her sons to the city of Groningen, where Werkman remained for the rest of his life.

An attraction to printing manifested itself early in life. Werkman's younger brother Martinus Hendrik wrote that one of his earliest childhood memories was of Werkman printing a newspaper during a winter evening under lamplight: "The secret world of printing types must have attracted him even though he had barely turned eight … Here for the first time, and often later, the inclination toward printing and graphics would emerge out of a deep subconscious."[5]

At the age of 18, Werkman began working as a routine type sorter, or "printer's devil", for a printer, publisher and bookseller in a nearby town. He also wrote occasional pieces for the company's newspaper and helped to set the type for it. On the side, he dabbled in photography, going so far as to print his own business card.

Title page of *Museum van plastische verzen* by Martinus Hendrik Werkman, designed, printed and published by H.N. Werkman in 1910, 23·6×18·8cm (10×7½in).

Three years later, he found work as a journalist with two Groningen newspapers, and later recalled the period as "a dog's occupation for little money".[6] Despite Werkman's distaste for journalism, the newspaper experience nurtured his love for printing, eventually helping him to secure a more lucrative job as shop supervisor for a printer in Wildervank, another town near Groningen.

In April 1909, Werkman married Jansje Cremer, the daughter of a Groningen family that had prospered in the hardware business. Although he had bought a small printing company in Groningen in 1908, with his mother's help, Werkman was not considered a desirable "catch" for a comfortable Dutch middle-class family of the time. The company had begun with ten workers, among them Wybren Bos who would carry on the business after Werkman's death. At the time of Werkman's marriage the business was struggling, but since it was important to Jansje's father that his son-in-law succeed, Cremer provided loans and operational expertise. The firm flourished and by 1917, with 27 employees, Werkman was by all appearances the exemplary businessman. In fact, he was never interested in making money. His father-in-law kept the company solvent and Werkman reacted more with annoyance than appreciation when Cremer's auditors inspected his ledgers.

Werkman became a proficient craftsman, but traditional printing was not his passion, and his early output differed little from that of other local printers. A few books, such as a volume of poetry by his brother, Martinus Hendrik, *Museum van plastische verzen* (Museum of Plastic Verse), were creditable design and printing achievements, but he was never even closely ranked among the best Dutch book designers of the period such as S.H. de Roos, J.F. van Royen and Jan van Krimpen.

Jansje died of a stroke in April 1917, leaving Werkman with daughters aged two and six and a five-year-old son. Within six months he married Pieternella (Nel) Supheert, and taking another bride so soon after Jansje's death caused an irreparable rift with Jansje's father. Werkman felt obligated to repay Cremer in one lump sum and went heavily into debt doing so. The rupture brought an end to Cremer's management skills, a herald of calamity considering Werkman's ambivalence towards business matters. According to Martinus Hendrik, Werkman was forever torn between two personalities, "the respectable businessman in society and that of the free bohemian".[7]

Initially motivated by a Van Gogh exhibition he had visited as far back as 1896, Werkman was encouraged by Nel to take up drawing and painting. This brought him his first contact with the Groningen art circle De Ploeg, which had been established in June 1918 to bring artists together and encourage regional art. Werkman was commissioned to design and print the group's *Statuten* (Statutes), and although most members looked upon him as a "Sunday painter" Werkman joined De Ploeg in 1919. Other members included the painters Jan Wiegers, Johan Dijkstra and Jan Altink; drawing instructors Jan G. Jordens and Jannes de Vries; house painter Jan van der Zee; teacher Johan van Zweden; and architectural draftsmen Wobbe Alkema and Job Hansen. Werkman printed De Ploeg's first catalogue in 1919 and in 1920 was included in one of their exhibitions.

Although the name of the art circle was omitted, Werkman printed and published at his own expense a magazine for De Ploeg titled *Blad voor kunst* (Magazine for Art) from October 1921 until March 1922. There were six issues, publishing woodcuts and photographic reproductions by De Ploeg members and articles on subjects including the Belgian poet Paul van Ostaijen. The magazine's content indicated that Werkman and other De Ploeg members were surprisingly well informed about what was taking place in the art world beyond Groningen. Some business trips to Amsterdam in the early 1920s could have exposed Werkman to the avant-garde through exhibitions at the Stedelijk Museum. There were also exhibitions in Groningen, including one visited by Werkman in February 1922 that displayed works by Vilmos Huszár, Theo van Doesburg and Bart van der Leck, three of the founding members of De Stijl. Werkman's design for the title page and cover of the last issue of *Blad voor kunst* may well have been inspired by Huszár's work.

Those who knew Werkman were hardly surprised when his printing company collapsed in 1923. Willem Sandberg later commented that anything practical was beyond Werkman's grasp and Werkman's assistant Bos recalled how when some new company stationery had arrived with the telephone number missing, Werkman's nonchalant reaction was, "Oh well, just leave it as is. I've already had enough bother with that telephone."[8]

The cost of a new press ordered from Germany had been especially devastating for Werkman. In the sales contract, a clause linked the price to inflation in the Weimar Republic and Werkman had to pay ten times more than anticipated.[9] Werkman avoided bankruptcy

28

28

11

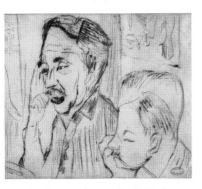

Drypoint by Jan Wiegers of H.N. Werkman and Johan van Zweden, 1924, 21·4 × 26 cm (8¹₂ × 10¹₄ in).

but almost everything had to be liquidated. He retained only two employees, one being Bos, and moved the remnants of his business to a seventh-floor loft in a warehouse along a canal. According to his brother, Werkman "then began to live according to his own philosophy, sincerely and frankly, and to again seek his solace in an art form that he had cultivated and developed on his own, and one in which he would find compensation for all of the misery in his life".[10]

Ironically, Werkman's adversities became a form of salvation, giving him a fresh sense of independence. He later wrote that although the 1920s constituted his most destitute period it was then that he "realized that the better purposes in life are to be found somewhere else".[11] Werkman had always used printing to serve his clients but now realized that he had never treated it as his heart demanded. At the age of 41, he experienced an epiphany, and the means that had once only afforded him a living now became an artistic tool. The Belgian artist Michel Seuphor, pseudonym of F. Berckelaers, the publisher of *Het Overzicht* (The Review), soon became one of Werkman's most active correspondents and his main link with the European avant-garde. Werkman wrote to Seuphor in 1930: "It seems that my objective in life has become to redress myself for all that I have overlooked until now and could have done."[12] The two discussed their financial straits, Seuphor explaining how he and his collaborator Jozef Peeters had endured great hardship and Werkman responding with optimism: "We have also been experiencing some uneasy times lately, but aware of the irrelevance of all these things, we attempt to lose ourselves in our work and in the joy of life."[13]

For Werkman, 1923 was a turning point when the past was closed and the future lay open. On 12 September of that year, a simple flyer was delivered to Werkman's colleagues in De Ploeg. Opening with "GRONINGEN BERLIN PARIS MOSCOW 1923 – Beginning of the Violet Season", it announced a new publication and declared the dawn of an artistic epoch: "It must be attested and affirmed … Art is everywhere." Beginning with the second issue this publication would be titled *The Next Call*, the slogan of Werkman's entreaty for a new artistic beginning.

"To view *The Next Call* as a 'cri de coeur' is no exaggeration", Ad Petersen wrote in his book on De Ploeg.[14] Werkman later reflected on the significance of this period for him: "Like a wet poodle I shook

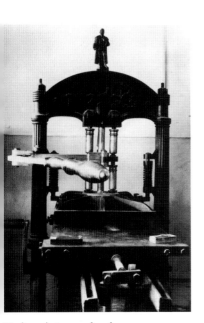

Werkman's German hand press
manufactured by Christian Dingler in 1850.

off everything that for me was annoying and stood then for a while
virtually alone. To tell the truth I did not understand it myself at
times. Still I continued: everything that you now lose is gain … "[15]

New art movements were then flourishing in Berlin, Paris and
Moscow, major cultural centres of the time, and although Groningen
was comparatively insignificant, Werkman hoped that something
similar could take root there as well. However, in 1923 Groningen was
a provincial city and attempting a publication there such as *The Next
Call* was a bold endeavour. Werkman wrote to Seuphor in 1924,
lamenting the parochialism of his environment: "Much to my regret
I have to admit that Groningen sits in a corner which almost no sound
penetrates."[16] Or as the poet Hendrik de Vries (also a Groninger)
wrote, "Only one who derives his energy from his own loneliness can
thrive here", a fitting description of Werkman.[17]

One objective of *The Next Call* was to generate innovation and force
certain De Ploeg members to shake off their complacent demeanours
and question the legacies of their academic training. Its abrupt
appearance was provocative in itself, but afterwards most of De Ploeg
dismissed it as a curiosity produced by an eccentric colleague. What
The Next Call did do was provide Werkman with an outlet for his
experimental typography and his few attempts at poetry. It was also
a convenient way to keep abreast of the international avant-garde.
Most of all, however, it kept Werkman spiritually alive in what was
for him a claustrophobic and provincial environment.

From 1923 until 1926, *The Next Call* was published in nine random
issues in editions of around 40 copies and was sent without charge.
The first four issues were distributed mainly to De Ploeg members,
friends and business acquaintances, but with the fifth number it was
sent to the editors of other avant-garde publications, both in the
Netherlands and abroad. The first issue articulated in large, uneven,
uppercase sans serif letters Werkman's present frustrations with his
immediate milieu and his future outlook:

EEN RIL DOORKLIEFT (a chill permeates)
HET LIJF DAT VREEST (the body that fears)
DE VRIJHEID VAN DE GEEST (the freedom of the soul)[18]

Werkman produced *The Next Call* on a German hand press made
in 1850 by Christian Dingler. By treating type as an artistic element
in its own right, independent of its logical communicative function,

13

30

he began to blend traditional letterpress printing with a technique in which paper was placed face-up on the press bed. This enabled previously inked letters and design elements to be manipulated by hand. Variable impressions, inking and letter spacing also made each copy of *The Next Call* slightly different.

32
The second instalment was mailed on 6 October, with *The Next Call* as the title. Two of the pages showed human-like figures built from type and a couple of years later related figures would be used in *Die Scheuche* (The Scarecrow) a Dada-inspired children's book by Van Doesburg, Kurt Schwitters and Käte Steinitz (also published as *Merz* no. 14/15).

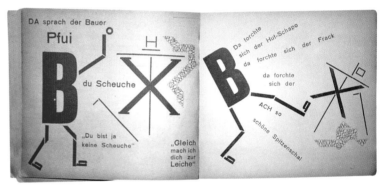

Inside spread from *Die Scheuche* by Van Doesburg, Kurt Schwitters and Käte Steinitz, published by Schwitters in Hanover, Germany, 1925 (also as *Merz* 14/15), 24·4×26·2 cm (9¹⁄₂×10³⁄₈in).

The fact that Werkman's art invariably originated during the printing process distinguished him from Constructivists such as El Lissitsky, Paul Schuitema and Piet Zwart who worked from deliberate designs. As Werkman would later write, "the subject proclaims itself and is never sought".[19] Although later there were sometimes rough preliminary sketches, Werkman's designs did not precede arrangement of typographic elements and printing and instead were part of the same aesthetic act. "Do you know the difference between me and others?" he wrote in 1941. "They are designers who do not work at a press and instead leave the production to others, while I produce designs during the course of printing."[20] In the words of the Dutch printing historian and typographer Dick Dooijes, Werkman "used common things in a completely uncommon manner and in this way achieved a very uncommon, innate artistic form".[21]

It is highly likely that Werkman was aware of the 1923 Dutch Dada tour conducted by Van Doesburg and Schwitters, since they came for one evening to Drachten, a town close to Groningen. However, Werkman never considered himself a Dadaist, emphasizing in the first issue of *The Next Call* that his publication "arose from the tempo

The envelope for the fourth issue of
The Next Call, 24 January 1924, 23 × 28 cm
(9 × 11 in).

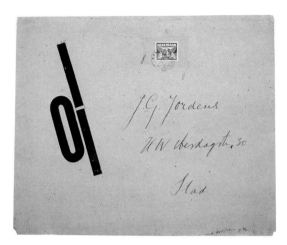

of the times and is not a triviality. It is not a repetition of the Dada joke; it is not a mockery."[22] While the Dadaists maintained they were not making art, Werkman deeply believed in the aesthetic relevance of what he was pursuing even though he would, at times, question its validity. "Although it will most likely occur in the distant future, I would happily live to witness an exhibition of everything I have created and still hope to create, if only to arrive at the conclusion: is it anything and does it mean anything? For me that is an essential question …"[23]

Like Werkman, artists such as Van Doesburg, Lissitsky, Jan Tschichold and others rejected the constraints of previously accepted typographic conventions such as classical page proportions and serif typefaces, yet, unlike Werkman they actively proclaimed new and often inflexible aesthetic and even social criteria. A fervent and unrelenting advocate of artistic freedom, Werkman had no desire to suggest new theories or reform society. Treating the letterpress as a painting tool and ink like paint on a palette, he freely seized upon whatever was needed to achieve a desired result. Yet, even though his playful and serendipitous approach was far from Constructivist, by utilizing the intrinsic features of printing material he supported the Constructivist belief that a work of art should respect the character of its medium.[24]

34 The third number of *The Next Call*, mailed on 12 January 1924, was visually the least captivating. Published only twelve days later,

35 *The Next Call 4* is more provocative, with lively contrasts of type style, direction and size. A composition on pages 2 and 3 is a sober memorial to Lenin's death on 21 January 1924.

The fifth issue of *The Next Call* was the first to be mailed beyond Groningen. Werkman did not realize that a letter he received from "I.K. Bonset" in response to this issue had been sent by Van Doesburg, using one of his pen names. Van Doesburg signed the letter with "Dadaist greetings", as if to suggest that he and Werkman shared some common cause. Failing to grasp Werkman's playfulness in signing the issue with the French "Travailleur & Cie" (Workman and others), Van Doesburg reacted with characteristic arrogance: "When and however it would be plausible to restructure your magazine in a more dadaist path I would be glad to help you, also in sending it to addresses of conceivable interest such as: Picabia, Tzara, Arp, Schwitters, Richter, etc ... Typographically I find a lot to admire in your publication, notably page 4. However, it does not make a good impression when you neglect to mention the names of the collaborators at the beginning of your magazine. Every clandestine action is a priori rejected."[25]

Van Doesburg was notorious for his competitiveness with his contemporaries and the fact that *The Next Call* was not included in the bibliography published by Van Doesburg in the *De Stijl* journal in 1924 and 1926 might imply that he considered Werkman a rival.

The envelope for the eighth issue of *The Next Call*, 23 February 1926, 22 × 26·2 cm (8⅝ × 10⅜ in).

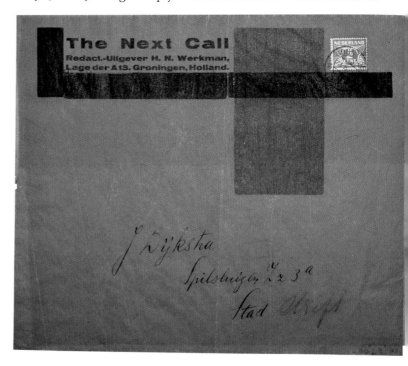

Van Doesburg did, however, get a reaction to his letter. In the next
issue "Travailleur & Cie" was replaced by "Edit. – Publisher H.N.
Werkman, Lage der A. 13, Groningen, Holland". By this time,
Werkman had abandoned any hope of support from fellow De Ploeg
members, an added impetus for discarding "Travailleur & Cie".

In exchange for *The Next Call*, Werkman soon began to receive other
avant-garde publications and writing to Seuphor in 1924, he listed 30
addresses to which *The Next Call* was mailed and exchanged, even so
far away as Tokyo. There is no record of his having met any of those
outside of the Netherlands to whom *The Next Call* was sent and there
is very little indication as to how the publication was received. In a
letter to wartime friend Paul Guermonprez, he wrote: "I have amassed
a good collection of magazines from all over the world to remind me
of this time. I cannot read most of them, but the images and spirit
expressed in them is still refreshing." [26] Correspondence between
Werkman and the other editors usually never went further than
mutual requests for images and exchanges, yet Werkman was keen to
stress the fact that he had important international connections and
that his publication was no provincial anomaly. In the sixth issue of
The Next Call, distributed in 1924, he wrote:

> *The Next Call* sustains international communication with the editors
> of numerous avant-garde publications and subscribes to: *Het
> Overzicht*, F. Berckelaers and Jozef Peeters, Antwerp. *De Stijl*, Theo
> van Doesburg, Leiden. *Mécano*, I.K. Bonset, Paris. *Merz*, Kurt
> Schwitters and El Lissitsky, Hanover. *La Zone*, A. Cernik, Brünn
> Jullanov, Belgrade. *Zenith*, L. Mitzitch, Belgrade. *Blok*, H. Stazewski
> and others, Warsaw. *Disk*, K. Teige, Prague, and many others. [27]

Even someone as aesthetically removed as Jan Tschichold
expressed some interest in seeing an issue. Werkman also
corresponded with Piet Zwart who turned down some pieces
Werkman submitted to the *Internationale Werkbundausstellung Film
und Foto* (International Film and Photo Work Federation Exhibition)
at Stuttgart in 1929, vainly suggesting in a follow-up letter that
Werkman take up photomontage.

The Next Call number 7 came out in February 1925, again as a
fold-out. Although dated September 1925, the eighth installment
was not mailed until February 1926. Printed in a larger and more
vertical format, the ninth issue brought *The Next Call* to an elegant

conclusion. Tinged with bitterness, Werkman began this issue with a poem that foretold the end of the series and encapsulated his own sense of disappointment:

> struggling is useless
> struggling is not useless
> not struggling is useless
> not struggling is not useless
> useless struggling is useless
> useless struggling is not useless
> not useless struggling is useless
> not useless struggling is not useless …[28]

By now, Werkman had grown weary trying to make any impression on most of his De Ploeg colleagues. "For members of De Ploeg", Van Zweden later reflected, "Werkman served as a kind of artistic conscience; he protected them from becoming bourgeois too early and with his astute vision he breached the limitations of a menacing parochialism."[29] *The Next Call* never accomplished its mission to make De Ploeg more progressive, but there was some deference for Werkman's ingenuity. As Hendrik de Vries noted in 1945, "his colleagues in De Ploeg had as much admiration for him as their pedestrian states of mind would allow".[30] Werkman's biographer Hans van Straten summed up the relationship thus: "For him, *The Next Call* was a rebellious act against everything, against his existence, against the dire circumstances associated with his printing business, against Groningen and in a certain sense against De Ploeg. What he did as a member of the circle was, in effect, 'out of order': he began there to formulate an artistic ideal in a strictly personal manner …"[31]

Although most of the first five issues of *The Next Call* and some later publications criticized the academic stance of De Ploeg, Werkman continued to maintain his affiliation and friendship with its members. Part of his loft space often functioned as an open studio where De Ploeg members could make use of his etching press and draw and paint from live models.

During Werkman's lifetime, the people of Groningen could broadly be described as cautious, a characteristic borne out by the old Dutch saying "Wat de boer niet kent, dat vreet hij niet" (What the farmer doesn't know, he doesn't gobble). *The Next Call* did not impress those members of De Ploeg who were Groningen natives and most reacted

with incredulity. Only Job Hansen, who contributed to three issues, and Jan Wiegers, who wrote texts for two, seemed to grasp Werkman's mission. To the others, Werkman was simply an amateur painter seduced by the avant-garde. Werkman later sadly wrote: "In spite of the fact that many of the things produced in this period seem somewhat mad in retrospect, *The Next Call* was never intended as a joke. Otherwise, with vacillating self-confidence, I would never have been able to continue."[32]

After Werkman's death, Martinus Hendrik lamented his failure to appreciate his brother during his lifetime: "With his difficulties and his smile, with his doubt and his perseverance, with his stoic wisdom, he has become a memory, a memory that could have meant more, but then we both would have to have been different [people]. That his life and his work has been of great meaning and value for others is a consolation in the sad realization of the deficiencies of our lives."[33]

Beginning in 1923, Werkman channelled much of his creative activity into making a series of over 600 larger monotypes which he called "druksels", a name concocted from the Dutch infinitive *drukken* (to print). Until the early 1930s, these were created mainly from typographic material, and by manipulating printing pressure, inking methods and density Werkman could attain an elaborate orchestration of tone and stratums. He later described his method: "I use an old hand press for my prints; so the impression is done vertically, and the impression can be regulated instinctively. Sometimes you have to press hard, sometimes very lightly, sometimes one half of the block is heavily inked, the other half sparsely. Also, by printing the first layer of ink on another sheet of paper you then get a paler shade, which is used for the definitive version … Sometimes a single print goes under the press fifty times."[34] Ink took on a function similar to layers of paint, and Werkman experimented with an unlimited number of shapes and colours in infinite variations.

Although his daughter Fie recalled how her father had walked in excitedly with the first druksel, Werkman was reluctant to display the prints and only did so for the first time in October 1925 in an exhibition at the Prinsenhof Gallery in Groningen. A review in the *Provinciale Groninger Courant* indifferently referred to them as "pleasantries rather than serious work" and the majority of De Ploeg members saw the druksels, and Werkman's work in general, as amusing curiosities by the head of a printing firm. The druksels were not part of any previous category and with them Werkman found his

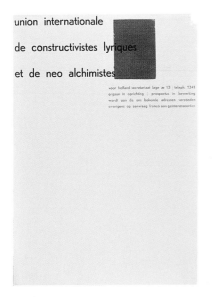

Letterheads by Werkman: [LEFT]
1929–39 design for the International
Union of Lyrical Constructivists and
Neo Alchemists; [CENTRE] Werkman's
own letterhead, 1924; [RIGHT] a 1927 design,
shown here in a 1939 letter to Helen Spoor.

own means of personal expression. Captivated by the printing process itself, Werkman at times seemed to endow his materials with the tactile beauty of sculpture. "There is paper so beautiful," he once wrote, "that one only wants to stroke it and otherwise leave it untouched".[35]

The druksels were, in effect, collages created on the letterpress and in this sense can be compared to the work of Schwitters during the same period. As Schwitters combined cut and torn paper, as well as other found components, into new aesthetic configurations, so Werkman gave new life to his everyday type shop materials through having them perform new functions. The druksels might also be compared to a small number of abstract prints that Zwart made in 1926, although the approach is quite different. Unlike Werkman, Zwart made use of modern printing methods and was not interested in paper textures and peculiarities of wood grains. He meticulously controlled the production process by using an impersonal, Constructivist approach and working closely with the printer. Werkman, by contrast, had a painter's temperament and obeying the dictates of his inner sensibility positively welcomed the accidental.

Between 1923 and 1929, Werkman made drawings using a typewriter, labelling them "tiksels" from the Dutch infinitive *tikken* (to type). These were created at the same time as similar constructions that appeared in *De Stijl* by Pietro (de) Saga, (pseudonym of the Austrian artist Stefi Kiesler). However, while those in *De Stijl* could be described as sound poems, Werkman's tiksels were pure abstractions.

Werkman's precarious financial straits at times had an impact on what he produced and the tiksels were indeed economical aesthetic solutions. Also, because of late payments to paper and ink suppliers, he sometimes had to print on wrapping paper using a limited number of colours, a harbinger of hard times for all Dutch printers during the German occupation.

Werkman's dream to abandon the business world never materialized and, investing in a more modern letterpress in 1927, he continued working as a commercial printer to earn a living. However, in the posters, invitations, birth announcements, brochures, calendars, bookplates,catalogues and stationery his creative side always found expression.

In November 1926, Seuphor offered to exhibit Werkman's druksels, or "compositions imprimées", in Paris. Almost a year later, Werkman modestly responded that his work was not viewed particularly favourably by those in Groningen: "Except for a few painters and architects they are seen and appreciated by only a few people." [36] The exhibition never took place, but Werkman, who virtually his whole life remained on the peripheries of the European cultural mainstream, did make his one trip outside of the Netherlands in August 1929 accompanied by Wiegers. The initial purpose of the trip was to see the modern art collection at the Folkwang Museum in Essen and the return trip included Cologne, Paris and Amsterdam. Sketching in Paris cafés and visits to museums and galleries made it a fruitful journey for Werkman, but he was disappointed not to see Seuphor, who was away. In April 1930, however, Seuphor showed two of Werkman's druksels from his own collection in a Cercle et Carré exhibition that he organized at Galerie 23 in Paris. Werkman was included among such luminaries such as Hans Arp, Sophie Taeuber-Arp, Vilmos Huszár, Wassily Kandinsky, Antoine Pevsner, Le Corbusier, Fernand Léger, Piet Mondrian, Kurt Schwitters and F. Vordemberge-Gildewart but unfortunately was barely noticed.

Werkman's second marriage broke down in 1930 and, dreaming of a simpler life inspired by Gauguin, he talked to friends about moving to Tahiti. In anticipation, he resigned from De Ploeg on 15 January 1932 and on the suggestion of Van der Zee was made an honorary member. After the Tahiti chimera evaporated, Werkman was re-enrolled as an active De Ploeg member and lived his Tahitian dream through a series of three prints entitled *Zuidzee eiland* (*South Sea Island*).

Working more figuratively than abstractly, Werkman started to experiment with new techniques. His work retained its candid simplicity but gradually became more refined. The two 1932 *Proclamatie* (Proclamation) pieces, manifestos promoting a new version of *The Next Call*, reflect this transition.

64

In a new druksel series entitled *Hot Printing* after a then popular term "Hot Jazz", the ink roller became a ubiquitous artistic implement. Werkman also increasingly used stamped type and in 1934 introduced stencils. Continuing a technique he began with *The Next Call*, he modified printing elements by partially covering them with pieces of paper. Dr. Ate Zuithoff, who worked at the University of Groningen and who met Werkman in late 1940, described the new approach:

> When I saw him in later years busy with a sheet of paper and an old razor blade with which the form was quickly and easily cut out, it seemed as if he was working with a pencil, so skilfully did he manipulate the contours. The cut-away as well as the cut-out piece were both used.

> Applying the ink to the roller was done by rolling it back and forth over a zinc pallet on which the ink had been mixed. The manner of rolling and the separation of the ink provided diverse nuances and made it possible to spread out the colours. This resulted in a coloured form or a recess in a coloured area that eventually could be filled with another colour … With most of the prints he first made a small sketch with a fountain pen on a calendar page. The colours were already envisioned in his fantasy …[37]

In 1938, Willem Sandberg, at the time conservator at the Stedelijk Museum in Amsterdam, visited Werkman after having seen his druksels. He bought several pieces and arranged for Werkman to have a solo exhibition at the Helen Spoor Gallery in Amsterdam. The exhibition in 1939 was hardly noticed and the only praise came from a critic in the Amsterdam newspaper *De Telegraaf* who wrote: "His typographic art is a serious game."[38] At the opening, Werkman re-united with Wiegers who had moved from Groningen to Amsterdam in 1934. Like Werkman, Wiegers had become dismayed by the conservative drift of De Ploeg, yet unlike Werkman he had made the decision to leave Groningen.

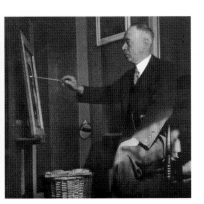
Werkman at his easel, c. 1939.

On 10 May 1940, Germany invaded the Netherlands and began a five-year occupation. Although all publishing was rigorously controlled, numerous clandestine presses defiantly produced printed material and money for the resistance. Production means were limited and a shortage of paper made printing anything especially difficult. All printers were forced to turn in 200 kilograms of their lead type to be used for bullets, a particularly hard measure for Werkman whose lead supply was already limited. From the very beginning, the war and the occupation greatly affected Werkman, deepening his innate sense of isolation and depleting the optimism that had so long been a source of strength. He became increasingly indifferent towards his business, and the few jobs that came along were usually delegated to Bos.

At the end of November 1940, Werkman was approached by Henkels to participate in a publishing venture that was to become the spiritual conclusion of his creative achievement. The idea, initially conceived by Henkels, Dr. Ate Zuithoff and local school teacher Mevrouw Adri Buning, was to publish something to strengthen the spirit of the Dutch people during the occupation. Henkels and Werkman agreed on details of the first issue in a meeting that marked the beginning of a deep friendship. The project would eventually consist of 40 publications and was entitled *De Blauwe Schuit* (The Blue Barge), after a Hieronymus Bosch painting called *Die blau scute* (the Ship of Fools), on display in 1936 at the Boymans Museum in Rotterdam.

Despite some similarities, *De Blauwe Schuit* was quite different from *The Next Call* created almost two decades earlier. While *The Next Call* was by and large created from typographic material, *De Blauwe Schuit* took an illustrative approach. It was also a collaborative effort by Werkman, Henkels, Zuithoff and Buning (also helped by Amsterdam book dealer and publisher A.A. Balkema, who supplied some of the paper) whereas *The Next Call* was essentially the product on one individual.

There were eight publications from *De Blauwe Schuit* in 1941, followed by fourteen in 1942, eleven in 1943 and seven in 1944. The first number was distributed among friends as a New Year's token in January 1941. It was a simple design with a woodcut by Wiegers and a poem by the Dutch poet Martinus Nijhoff, *Het Jaar 1572* (The Year 1572), celebrating Princess Juliana's 25th birthday in 1934:

So the unusual year began
When everything turned out different from expectations.

Who had won already was vanquished.
Who conceived of sun and weather finally without thought.
Created a population, when he thought of digging a grave.
What happened has seldom taken place.
They stood behind water and behind walls.
They held out. They were all together. [39]

Throughout the war, *De Blauwe Schuit* was published and distributed openly, unlike most of the other clandestine publications. Werkman's name appeared on each issue, although the names of living writers were often deleted or changed and the numbers of editions were sometimes deliberately jumbled. Finding its message obscure, the Nazis ignored it.

In May of 1941, Werkman visited the Sandbergs in Amsterdam and, along with Wiegers, was honoured by being taken to the concrete vault near Sandberg's house in Castricum where art from the Stedelijk Museum was stored. Paintings by artists such as Van Gogh, Redon, Klee, Picasso and Cézanne ignited Werkman's creative drive and inspired him to begin the Amsterdam-Castricum series of druksels, his first since a one-year hiatus. A few months later, he began the 82 *Turkenkalender* (Turkish Calendar), distributed between Christmas and New Year's Day 1942 and inspired by a Turkish calendar published by Gutenberg in 1454 warning against a Turkish invasion of Europe.

88 The first of two *Chassidische legenden* (Hasidic Legends) portfolios was published in 1942, the triumphant finale of Werkman's oeuvre. Werkman had been introduced to Hasidic Judaism by Henkels who had given him the book *Hasidic Legends* by Martin Buber. Werkman was not religious in a traditional sense, but he was enchanted by Buber's work. Each of the *Chassidische legenden* portfolios consisted of conventionally printed texts and ten large illustrations individually created by an ink roller and stencils in an edition of 20. The first portfolio was initially displayed in a schoolroom at a local seminary and 16 copies were bought within two months despite a price of 75 guilders. (A young painter reputedly sold his bicycle to buy one, a significant sacrifice considering a bicycle's value during the war.)

96
100, 104 The second portfolio of the *Chassidische legenden* was published in 1943. This was followed by a calendar in 1944 and the *Nieuwjaarsbrief 1944* (New Year's Letter 1944). Werkman also continued to produce druksels, but typographic elements had practically disappeared from his work by this time.

In 1943, one of Balkema's more risky publications was *Zehn Kleine Meckerlein* (Ten Little Nuisances), a satirical text by an unknown author that was smuggled out of a concentration camp. Balkema printed the 40 copies himself on a small press. Its simplicity and directness are suggestive of Werkman's pieces for *De Blauwe Schuit*.

108

The last publication for *De Blauwe Schuit* – P.C. Boutens' *Reizang van burgers* (Round for Citizens) – was distributed in June 1944 and represented an ember of optimism in anticipation of an early liberation that did not come. By this time, electricity could hardly be produced in Groningen, and since there was no heating fuel either, ink hardened and became impossible to use. Other than a 1945 calendar and a few pieces for the underground presses – *In Agris Occupatis* (In an Occupied Land) and *De Bezige Bij* (The Busy Bee) – Werkman ceased printing by the end of that year.

109

During the occupation, Werkman had generally declined to print material for the underground, not out of fear, but because he felt others could be placed in jeopardy since his print shop was in a building with other businesses. On 13 March 1945, however, the Sicherheitspolizei (Security Police) arrested Werkman and Henkels and took them to the Scholtenhuis in Groningen, their headquarters. The pieces Werkman printed for *De Bezige Bij* and *In Agris Occupatis* possibly contributed to the arrest, but the main reason behind it was his identification with Jews through the *Chassidische legenden* and other publications for *De Blauwe Schuit*. When books by Dostoyevsky and other Russian writers were found in Werkman's house, his paintings and druksels were labelled as "Bolshevik art" and impounded along with personal documents.

Back page of A.A. Balkema's *Zehn Kleine Meckerlein*, 1943, 14·2 × 12·3 cm (5$\frac{1}{2}$ × 4$\frac{7}{8}$ in).

In early April, an order came from the SD headquarters at The Hague to execute 30 prisoners as a reprisal against the Dutch underground in Groningen. The first group of ten was taken to Anlo and shot before a firing squad on 8 April; the following morning the second group was executed. However, when the last ten were being driven that afternoon to the execution site, one managed to escape and the execution was delayed. Shortly afterwards, Werkman was chosen to replace the escapee and along with the other nine was executed near the town of Bakkeveen two days before Canadian forces entered Groningen.

During the liberation of Groningen, an explosion demolished the Scholtenhuis, and everything impounded from Werkman's house was

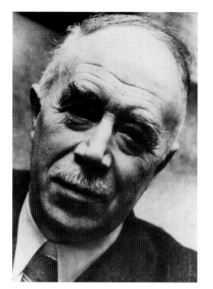

H.N. Werkman, 1943. Photographer: Nico Jesse.

destroyed. This included important documents, most of his collection of avant-garde publications, half of his paintings and a third of his druksels, the latter being equally irreplaceable since they were single editions. Fortunately, a cupboard filled with druksels was overlooked when Werkman's house was searched at the time of the arrest.

In 1945, prizes were instituted in Amsterdam in memory of Werkman and Duwaer, another printer who was executed during the war. The first Werkman prize, a permanent celebration of his artistic ideals, courage, humanity and legacy of typographic freedom, was posthumously awarded to Werkman. In September of the same year, Sandberg was made director of the Stedelijk Museum. One of his first acts was to hold a Werkman retrospective that autumn, publishing the first Werkman catalogue – Sandberg's own post-war design, especially his promotional work for the Stedelijk Museum, was to be profoundly influenced by Werkman. In 2000, Graham Wood, a member of the London-based design group Tomato, wrote that *The Next Call* was as "vital and alive as any typography since, with more heart and soul than anything resembling it today. Meaning, relevance, prescience, reason."[40] Since Werkman's death an awareness of his relevance to contemporary graphic design has steadily emerged, and his work has lost nothing of its richness, spirit and optimism. Werkman's simple acceptance of his own feelings and the unforeseen aspects of the design process has particular resonance today as graphic design undergoes a period of unprecedented technological innovation. The role of the individual and the communicative power of the human touch needs to be stressed more than ever before in graphic design of the 21st century.

Selected Work

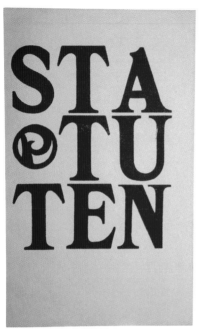

Statuten (Statutes)
Booklet
Publisher – De Ploeg
After March 1921, 21×13·1 cm (8¼×5⅛ in)
12 pages inc. front & back
[ABOVE]

This was the second edition of statutes printed for De Ploeg after Werkman became a member. The cover, shown here, displays the De Ploeg logo designed by member Ali Pott. This was selected as part of a competition in 1919 and was used in several versions. The bold use of type foreshadows Werkman's later typography.

Blad voor kunst (Magazine for Art)
Magazine
March 1922, 30·5×27·5 cm (12×10⅞ in)
20 pages inc. front & back
[BELOW]

The literary value of *Blad voor Kunst* was negligible, but it was the first attempt in Groningen to produce a magazine devoted to modern art. Werkman's striking cover consisting of black and yellow rectangles on a red background clearly reflects the influence of De Stijl. The use of purely abstract forms represents a major step for Werkman.

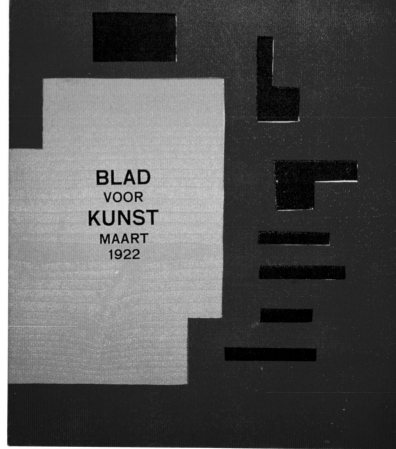

GRONINGEN BERLIJN MOSKOU PARIJS 1923

Aanvang van het violette jaargetijde

Lezer

Aangezien,

Overtuigd,

Aangezien wij dus overtuigd zijn dat het nog niet TE LAAT is, zullen wij spreken.

Het wordt tijd, waarachtig.

„ „ meer dan tijd dat er iets gedaan wordt. Er MOET getuigd en gesproken worden. Wij betreuren alleen dat WIJ dit moeten doen waar zoovele anderen het beter kunnen.

KUNST is overal. Zij wordt den mensch als het ware door de vogels op de jas geworpen. In elke zuigeling met zwakke ingewanden wordt de latente kiem gelegd voor een kunstenaar bij de gratie. Het kunst-emplooi gaat buiten alle perken en verstikt het gevoel der natie.

In vertwijfeling gaat gij neder, in wanhoop barst gij uit. Wat baat het U? Het handenwringen verlost U niet. Een orkaan kan de lucht zuiveren. Hij kome, dat hij kome!

Ons eerste geschrift verschijnt binnenkort. Wij noodigen U dringend uit medelezer te worden. Leesgeld vragen wij niet voordat de zon verrezen is. Wij rekenen op Uwe DADEN in het witte jaargetijde met de zwarte schaduwen.

Naar de DAGERAAD, als gij pionier wilt zijn.

Getuig.

Spreek.

Wacht niet tot na het ontbijt, uit vrees dat Uw opgewarmde koffie koud zal worden.

Travailleur en Cie. (Corr.-adres Lage der A 13)

Aanvang van het violette jaargetijde
(Beginning of the Violet Season)
Flyer
Text – H.N. Werkman
12 September 1923
32·8 × 24·7 cm (13 × 9¾ in)
c. 40 copies

This flyer announced the publication of *The Next Call*. At the bottom of the sheet the publisher was listed as "Travailleur en Cie" ("Workman & Others" in French), but everyone knew it was Werkman from the address "Lage der A 13".

The Next Call 1
Booklet
Text – H.N. Werkman & Jan Wiegers
6 October 1923, 27·4 × 21·5 cm (10¾ × 8½ in)
8 pages inc. front & back, c. 40 copies

On the front, the impression of a lock plate
removed from the frame of a door suggests
an upper-case "E". The text within restates
Werkman's belief that Groningen could be
on a par with Berlin, Moscow and Paris.
The pages conclude with the cryptic text,
which, in translation, reads:

JOY OF
LIFE

Pray for Anguish
No Languishing from love;
Wasting worry,
Luxury of Woe.

Loathe triumph
Horseman's glow
Tomorrow the regret
Death in the cup.

front [LEFT]
pages 2 & 3 [BELOW]
pages 4 & 5 [OPPOSITE TOP]
pages 6 & 7 [OPPOSITE BOTTOM]

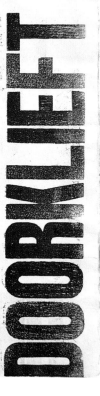

GRONINGEN
1923 Groote Verzoendag

Tot deze AANVANG was besloten reeds voor de
eerste symptomen van de jubileumgolf met de ont-
eerende persoonsverheerlijking zich voordeden.
Meen dus niet dat gebeurtenissen van al te recen-
ten datum die ge in Uw beperkt gezichtsveld mocht
bespeuren, aanleiding gaven tot het rose pamflet.
Het ontstond uit den drang des tijds en is geen
aardigheidje. Het is geen herhaling van het Da-
daïstisch grapje; het is geen hoon.
Het ontstond met moeite, want wij zijn traag, hoe-
wel de tijd dringt. Het zomerlanterfanten is gedaan.
Mocht het een REVEILLE zijn in den tijd van
afwachting.
Meewarig of verachtelijk, het zou in elk geval
verachtelijk zijn, langer te zwijgen.
Getuigen en spreken.
Maar 't GELUID KAN NIET SCHOON ZIJN en de
TAAL KAN NIET VERSTAANBAAR ZIJN voor
wie niet luisteren WIL als hij niet spreken KAN.
Wat gij van ons verlangt kunnen wij U niet geven.
Dit is de AANVANG.
Voet voor voet. Stap voor stap.
Uit de beklemming van de kunst, het parool.

BERLIN
Am dritten Montag

Heute habe ich mich frisch rasiert.
Ich hasse die Weiber, weil ihre Schönheit mich banget.
Einen wirklichen Freund habe ich nie besessen.
Die Einsamkeit ist nicht mild.
Ruhmlos ist die Ehre.
Die Augen sehen mich an.
Der Mensch glaubt ein psychologisches Rätsel zu sein,
statt eines banalen Säugetiers. Sein Instinkt nennt er
Verstand. Das verständige Raubtier. Das Automobil.
Censoren gibt es noch immer. Sie schleichen durch die
Sälen und spüren ängstlich mit der Nase ob irgendwo
die Kunst verletzt wird. Diese Dummköpfe. Man sollte
sie alle auffangen und ihnen in der Stillen Südsee die
Ohren waschen. Und noch etwas anderes.
Das publikum meint das zum Feiertag die Freude gehört
und fängt beim Leiden an zu weinen.
Also am nächsten Feiertag.

MOSCOW
Saxophoon en fagot

Nauwelijks is de nacht gedaald of gij verlangt den dag
te zien. Wees stil met Uw vrees. De wit-gesteven
opzetteugel zal U thans niet kwellen voor een poos en
de spiegel is gehoecd te Uwer eer. De versenbouwer
is naar 't gemaskerd bal en laat zijn hoofdhaar streelen
door schoone vrouwen. Begeef U naar den achtergrond
en hoor de stem die in de kamer komt. Zij zal U lafaard
noemen, maar gij behoeft niets te vreezen. Eens zal de
dageraad U wekken. Dan zult ge Uzelf weer kennen
en Uwe vrienden zullen niet meer bij U zijn. Als Uw
middenrif zal reageeren op den klank der dagen, kunt
ge veilig gaan, verlost van 't koord waaraan ge U leiden
liet. Dan wordt Uw naam gedragen en zult ge sterk
staan en niet vluchten. Uw weg moet ge zelf zoeken.
Val niet. Hier is Uw kruis.

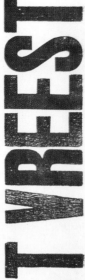

HET LIJF

DAT VREEST

PARIS
Le lendemain

Il fait un temps horrible.
C'est l'exécution de l'été. La neige douce et la pluie
sont les sanglots et les larmes de la foule autour de l'é-
chafaud. L'immense vent hurlant est le cri effroyable
du peuple au moment que la hâche est tombée.
J'aimerais mieux assister à l'exécution de l'art. Ça serait
une scène touchante.
Imaginez-vous que tous les gens qui se disputent sur
l'art seraient témoins de cette cérémonie. Je me méfie
de cette foule qui se mettra à crier et à pleurer. Savez
que les mêmes bouches chanteront au lendemain et se
disputeront de nouveau sur l'art. Ces messieurs parlent
de l'amour et adorent la cochonnerie, ces farceurs qui
n'ont jamais eu d'autre aspiration que de se préparer
pour un bon dîner avec du bon vin et une belle femme.
Assez de ces méditations sentimentales, l'histoire se ré-
pète toujours, l'été prochain sera encore plus beau et
mourira au fin. L'art se rend et ne meurt pas. Rien
de nouveau sur ce monde.

LEVENS VREUGD

Smeek om smart,
Geen liefdesverwijnen;
Verwoestingswee,
Weelde van lijden.

Haat overwinning
Ruiters roes.
Morgen de wroeging,
Dood in de kroes.

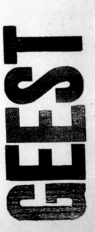

GEEST

DE VRIJHEID VAN DE

The Next Call 2
Booklet
Text – H.N. Werkman & Jan Wiegers
6 October 1923, 27·2×21·5 cm (10¾×8½in)
8 pages inc. front & back, c. 40 copies

The text on page 3 in this installment of
The Next Call assails contemporary society:

Listen to the laughter.
Above all the bayonets, all the golden collars
the free spirit moves throughout the world.
All merchants, bailiffs, conceited constables
and clerks of court, all those who wear caps
and gowns shall be compelled to heed the laughter
of the accused and prosecuted, and the tumult
will be so loud in their court-rooms that, after
stupidly gazing, they will never be able to shut
their jaws again.

On page 6, "Paris" is printed above a
construction made from "LE BOULEVARD"
and then covered with a rectangular paper
fragment, demonstrating that Werkman
modified pieces after printing.

front [RIGHT]
pages 2 & 3 [BELOW]
pages 4 & 5 [OPPOSITE TOP]
pages 6 & 7 [OPPOSITE BOTTOM]

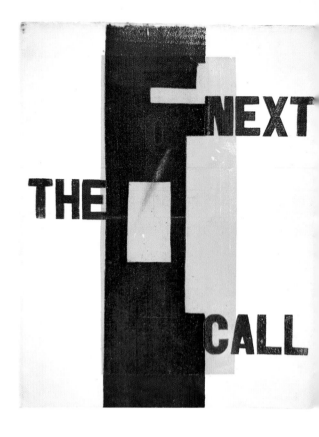

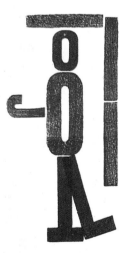

Groeiende Lach

October 1923

Ondanks de kunst. Want de kunst heeft veel op haar geweten.
Ondanks de pers. Want de pers is nog schuldiger domper.
Altijd hebben ze samen geprobeerd elke goede kiem te verstikken,
elke goede gedachte te verslijmen en elke goede daad te vermodderen.
De epidemische hersenverweeking en de ontzettende leververdorring
komen voor beider gezamenlijke rekening.
Maar desondanks wordt er reeds tamelijk veel gelachen in deze wereld.
Vergeet dat niet bij 'tgeen gij doet en beschouw deze lach niet als
een hebbelijk verschijnsel dat zich thans aan de hoeken der straten
openbaart.
Het heeft natuurlijk niets gemeen met het gedoe van den oppassenden
burgerman die met zijn weldoorvoede vrouw in de stijlvolle kamers
hokt, welke noodig een uitmesting behoeven.
Het is de lach van de vrijgeworstelde bij het zien van de pogingen
om de vrijgaande geest het evolueeren te beletten.
Nog flaneert het geganteerde officiertje ridicuul door de hoofdstraten.
Nog imponeert de bureaucraat en handhaaft zijn gezag.
Nog duldt de beer de ketting om zijn hals.
Nog gaat in schijnvertoon en onder inmaakleus de snijboon door de
straten.
Nog gaapt de kloot zich suf aan elke gouden kar en weet z'n functie
niet.
Zoo lomp gaat deze tocht door het moerasland voort en stoort zich
niet aan and'rer ergernis en sjoeksjakt naar z'n einde en vindt op
't laatst de dood.
Hoor de lach.
Over alle bajonetten heen, over alle gouden kragen gaat de vrije
geest de wereld door.
Alle handhavers, alle deurwaarders, ijdeltuiterige veldwachters en
griffiers, alle beffen, toga's en baretten zullen aanhooren den lach
van de gesommeerde en vervolgde die zoo luid zal klinken in hun
rechtzaal dat zij hunne kaken na de stompzinnige aangaping nooit
meer kunnen sluiten.

Leg je masker af.

Treed in het volle licht der werkelijkheid mensch, met jou verfijnde hersenen. Heb den moed naar waarheid te getuigen van je bestaan.
Door je zelf ben je vervloekt indien je dit niet doet.
Ik heb jou hulp noodig als kameraad ontdaan van het masker der beschaving en aesthetische aanstellerij.
Je kunt verzekerd zijn van mijn hulp. Alleen door werken kun je mij helpen in dienst der geestelijke vrijwording en ik zal je medewerking naar juiste waarde weten te schatten, gelijk wie je ook bent. President, keizer, koning of hoer. J. W.

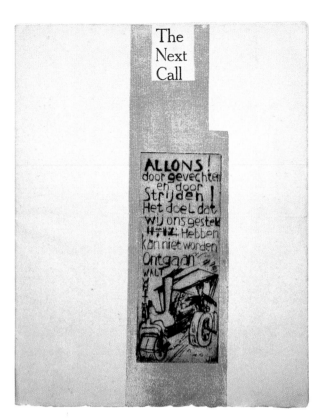

The Next Call 3
Booklet
Text – H.N. Werkman & Job Hansen
Poem – Walt Whitman
12 January 1924, 27·4 × 21·5 cm (10¾ × 8½ in)
8 pages inc. front & back, c. 40 copies

The lock plate that appeared on the first issue remains the central design element on the cover. Printed over it is a drypoint of a steamroller by Wiegers that Werkman combined with a handwritten Dutch translation of Walt Whitman's poem "Song of the Open Road".

ALLONS! Through struggles and wars!
The goal that was named cannot be
countermanded.

front [LEFT]
pages 2 & 3 [BELOW]

Hoera
voor
de Fresco's

Three cheers for the Fresco's,
Wat beteekenen Fresco's voor
de stad Groningen.
Punt van attractie.
Bron van welvaart.
„ „ vreugd.
Hetzelfde als een echoput op
de Veluwe.
Daarvoor vraagt Het Comité
slechts vier duizend gulden.
Blank en gaaf 4000.
Voor een nationaal belang, voor
het vreemdelingenverkeer, voor
Baedeker en de ansichten is dit
niet te veel.
Welwillende kranten, slooft U
uit, span U nog éénmaal in en
druk de geversnamen vet.
Dan zullen ze er komen. Dan
is er veel eer behaald, veel
officieele eer. Dan kan er weer
rustig voortgeleefd worden.

Nochtans ware het beter deze
fresco's met versche kalk te con-
serveeren en voor de resteeren-
de gelden moderne wanddeco-
raties te doen schilderen in de
openbare gebouwen van de stad.

Maar daarvan is de rede niet.

Koketterie
en IJdelheid

openbaren zich in verschillende
vormen.
Zoudt gij meenen dat een echte
luis in staat zou zijn uit Koket-
terie het behaagziek lijf voor de
naderende trein te leggen om
zich te laten halveeren?
Zoudt gij meenen dat een on-
gedurige motvlinder de Koket-
terie zoo ver zou kunnen drijven
dat hij zich in een stille straat
door een stoomwals zou laten
plisseeren?
Zoudt gij meenen dat een levens-
lustige speelworm zich uit Zucht
naar Roem en Eer door het
noodlot zou laten vierendeelen?
Zoudt gij meenen dat een on-
geboren zoon uit Drang naar het
Martelaarschap zich in het moe-
derlijf zou wurgen in de navel-
streng?
Zoudt gij meenen dat eenig zoog-
dier Roeping voor het Kunste-
naarschap zou gevoelen?
Zoudt gij meenen det het nog
zin heeft één woord te spreken?

The Next Call 4
Booklet
Text – J. Hansen
24 January 1924, 27·2 × 21·5 cm (10¾ × 8½ in)
8 pages inc. front & back, c. 40 copies

On pages 2 and 3, two type columns constructed from "O"s and "M"s suggest troops escorting a casket, but as "oom" in Dutch means "uncle", it also implies an affinity with Lenin. Werkman was essentially apolitical but admired the Russian avant-garde. He saw the revolution there as an opportunity for a new beginning in the arts and often said that he wanted to visit Russia before his death. When questioned about the absence of "the social conflict issue" in his work, Werkman replied that he was "totally uninterested in depicting this conflict." [41]

The machine-like image on page 6 is Constructivist in feeling and reminiscent of a 1920 piece, *Collage R*, by Hungarian-born designer Moholy-Nagy. Hansen's text suggests the foundations of Constructivism:

flying machine
TODAY
Art and inventions XX century
Beginning of appreciation of flying-machine, motor
FINALLY
God created man
And man
Makes the objects
Constructivist art
 of the ob-
jects (without subjects)
ART AND TECHNOLOGY
Brand-new and
Topical

back & front [BELOW]

The Next Call 4 (continued)
pages 2 & 3 [BELOW]
pages 4 & 5 [OPPOSITE TOP]
pages 6 & 7 [OPPOSITE BOTTOM]

36

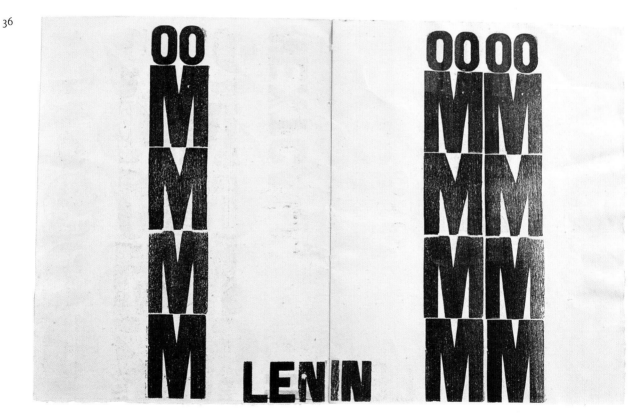

handel handel handel 1 2 3 handel handel handel 1 2 3 handel

J. H.

vliegmachine

VANDAAG

Kunst en uitvindingen XX eeuw

Begin van waardeering van vlieg-
machine, motor

EINDELIJK

God schiep den mensch
en de mensch
maakt de voorwerpen
Konstructivische kunst
„ der voor-
werpen (zonder onderwerp)
KUNST EN TECHNIEK
Gloednieuw en

Actueel

LENIN

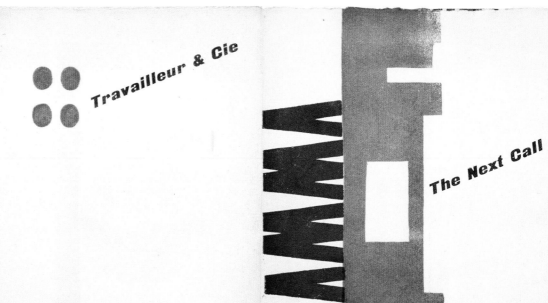

Travailleur & Cie

The Next Call

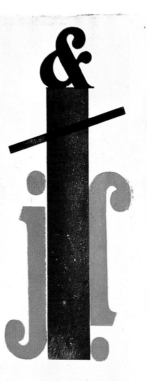

VANITE
HOTEL
du 1er ordre
Reaction
reaction
ZiE oP u zeLf
140 ton
jemaintiendrai Maandag
Maandag
breedsprakigheid
in alle talen
BELEEFDHEID
DEUGD
DIKKE TONG
rang
&
stand
HOUDING

The Next Call 5
Booklet
Text – H.N. Werkman
June 1924, 27·2 × 21·5 cm (10¾ × 8½ in)
8 pages inc. front & back, c. 40 copies

The familiar lock plate is seen on the
front and related angles in the setting
of *The Next Call* and "Travailleur & Cie"
show that the front and back were
printed simultaneously. On page 2
an ampersand appears to rest like a
typographic bird atop a vertical rectangle
and, while retaining their identity,
letters assume a monumental quality.
A Dadaist text appears on page 3, and on
pages 6 and 7 a cynical debit and credit
list refers to the dismal state of Werkman's
financial affairs.

back & front [OPPOSITE TOP]
pages 2 & 3 [OPPOSITE BOTTOM]
pages 4 & 5 [LEFT]
pages 6 & 7 [BELOW]

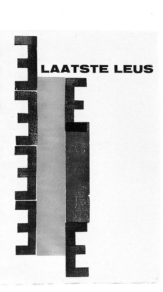

Lange dagen 1924
argo
cargo
radio
verzend- en
ontvangstation van
versche gedachten ter
vervanging van blue
band, en ter bestrijding
van houding, bangma-
kerij en bedorven lucht,
van beschavingscom-
promissen inzake kunst
en aanpassingstaktiek
nopens militaire crimi-
naliteit en deftige ver-
tooningen, zoo in duplo
als en masse, valsche
voorspiegelingen van
de pers en hare mo-
tieven; alles ter beves-
tiging van de zon in
haar baan

CCCGGGSSS

LAATSTE LEUS

17% dividend
10% analphabeten
2% aschgehalte
95% gesl. zieken
76-82% nuttig effect
101% kunstenaar
34% eigen schuld
resultaten: autostof en
tralievensters zijn geen
beleedigingen meer
voor het menschdom.

Positief

DADA

The Next Call

onderhoudt internationaal verkeer met redacties van onderscheidene Tijdschriften van de avant-garde en neemt abonnementen aan op:
Het Overzicht, F. Berckelaers en Jozef Peeters, Antwerpen. De stijl, Theo van Doesburg, Leiden. Mécano, I. K. Bonset, Parijs. Merz, Kurt Schwitters en L. Lissitzky, Hannover. La Zone, A. Cernik, Brünn Julianov, Zenith, L. Mitzitch, Belgrado. Blok, H. Stazewski e.a. Warschau. Disk, K. Teige, Praag, en vele andere.

Redact.-Uitgever H. N. Werkman,
Lage der A 13. Groningen, Holland.

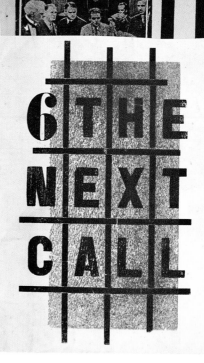

6 THE NEXT CALL

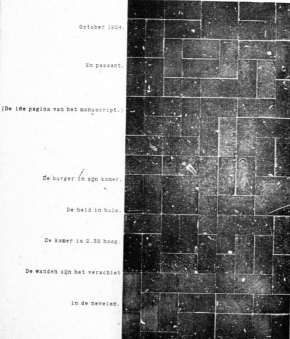

October 1924.

En passant.

(De 16e pagina van het manuscript.)

De burger in zijn kamer.

De held in huis.

De kamer is 2.35 hoog.

De wanden zijn het verschiet

in de nevelen.

Hij heeft zijn zondagen, elke week zes, behalve den Zondag. Zondag is de blanke pagina in het verschiet van elken Maandagmorgen.
Hij heeft zijn tijdverdrijf. Zijn motorboot en zijn rashond en de krant als convocatie. Per kolom à zooveel.
(De journalist is de bezoldigde bode met het onbezoldigd air en als het nog na zonsondergang zijn schaduw mee.)
Hij heeft zijn singels en de aproeiwagens met versnellingsnaaf. Zijn frissche ideeën over kunst en vier keer per dag de post. Het gironummer is zijn naamkaart, de loudspeaker zijn emotie, de historie zijn vertrouwen, buurmans oordeel zijn compas.
Het was Zaterdag toen de zon scheen en niet als een slecht voorteeken.
Hij neemt een besluit en zal den makelaar bezoeken en hem zeggen dat hij geen genoegen neemt met de overname van de grondbelasting over 't volle jaar bij de koop van het huis kadastraal bekend bij sectie en nummer. Repetitie: aanvaarding, enz.
Tweede sigaar, merk Hidalgo.
Hij weet den weg en rijdt op tijd, rechts.
Hij ziet den smid. (De smid maakt een grafiek en meet en past tot 't past. Een schroevenhater)
Hij ziet den rechter. (De rechter brengt zijn klanten tot bekentenis. Dat is zijn eerzucht en zijn tijdverdrijf. Het spel van den eed en de formule van de waarheid en niets dan de waarheid. Deurwaarder de volgende zaak!)
Hij ziet den dokter. (De dokter is een wijs man en kent de waarde van den glimlach zonder zwaarmoedigheid.)
Hij ziet den éénmanswagen, maar eerst de auto. (De auto eischt den weg. Het snelverkeer regeert en heerscht met stof en stank. De overweg wordt niet gesloten, de trein rijdt op de keien. De keienpletter knettert met internationale signaalentaal.)
Hij ziet den karreman het zweet zijns voorhoofds wisschen.
Hij ziet de brug en 't schip, den haringman met nieuwe-nieuwe, den politieken redenaar, den ambtenaar der registratie in druk gesprek, den voerman op zijn paard ongegeneerd gezeten.
Hij ziet per spiegelruit zijn eigen beeld.
De belangstelling van den voorbijganger.

The Next Call 6
Folded sheet
Text – H.N. Werkman & J. Hansen
October–November 1924
27·2 × 21·5 cm (10¾ × 8½ in)
Unfolded 43 × 54·4 cm (17 × 21½ in)
40 copies

This issue is printed on a single sheet and folded twice. Fragments from discarded printed pieces are pasted on the top, making each copy distinctive. When completely unfolded, Werkman's well-known composition of words, lines and rectangles, *Plattegrond van de kunst en*

omstreken (Map of Art and Environs) is revealed. The title came from a comment by Job Hansen while observing Werkman at work: "It looks like a map of art and its perimeters."[42] Werkman liked the association and made the words and blocks indicate land, streets and rivers. When partially unfolded, the inside spread shows a closely interlocked puzzle-like structure made from the backs of wood type. A text set in a typewriter font stresses Werkman's disdain for the bourgeoisie:

He has his Sundays, every week six, except Sunday. Sunday is the blank page in expectation of every

Monday morning. He has his diversions. His motorboat and his pedigreed dog and his newspaper as convocation …

back & front [OPPOSITE TOP]
inside spread [OPPOSITE BOTTOM]
fold-out [BELOW]

41

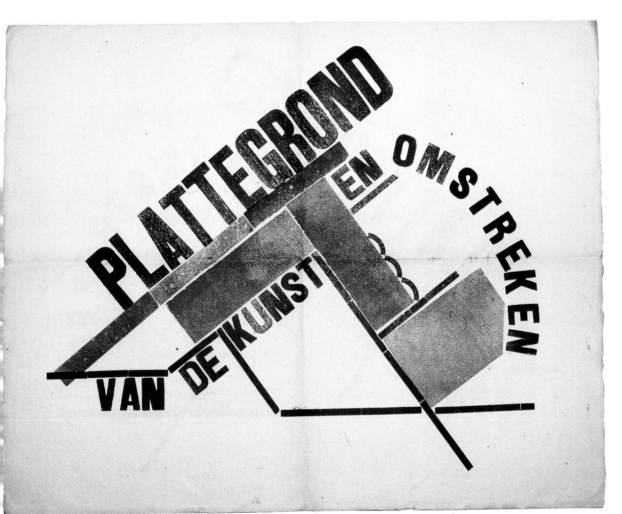

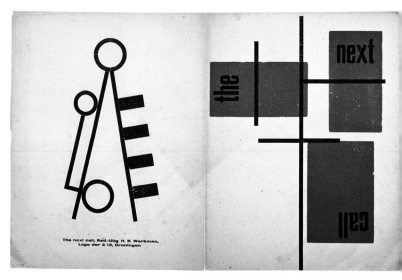

The Next Call 7
Folded sheet
Text – H.N. Werkman
February 1925
27·2 × 21·5 cm (10¾ × 8½ in)
Unfolded 43 × 54·4 cm (17 × 21½ in)
c. 40 copies

Werkman printed two variations of the
cover for this issue. There are also two
versions of the fold-out with variations
on Werkman's letter construction in
the centre being the only change. To
the left and right of Werkman's piece
are linoleum cuts by the De Ploeg
members Van der Zee and Alkema and
a photographic reproduction of a painting
by Van der Zee, the one occasion when
the three presented a united front.

When partially unfolded, the inside spread
reveals four rows of words and articles
methodically divided by the French words
"en face" (full-face), "en profiel" (profile),
"en detail" (retail), "en gros" (wholesale)
and by serial numbers "a", "b", "c" and "d".

back & front [TOP]
inside spread [RIGHT]
fold-out [OPPOSITE]

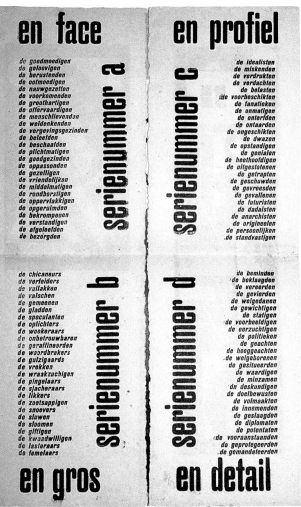

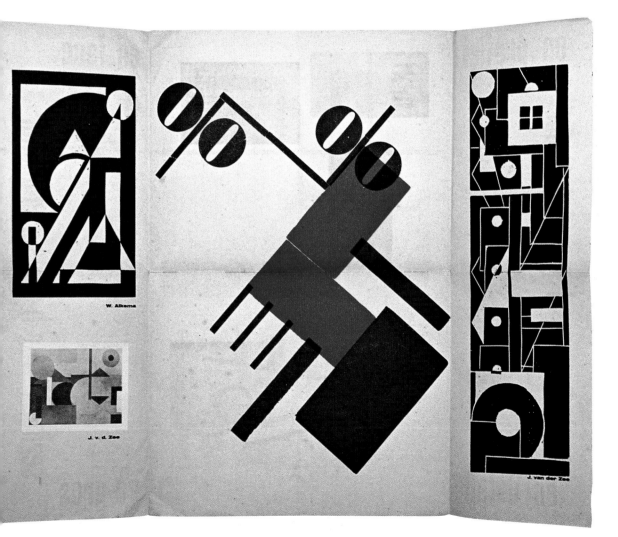

W. Alkema

J. v. d. Zee

J. van der Zee

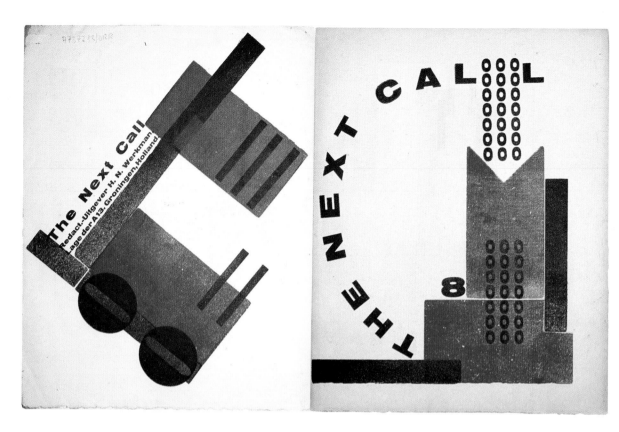

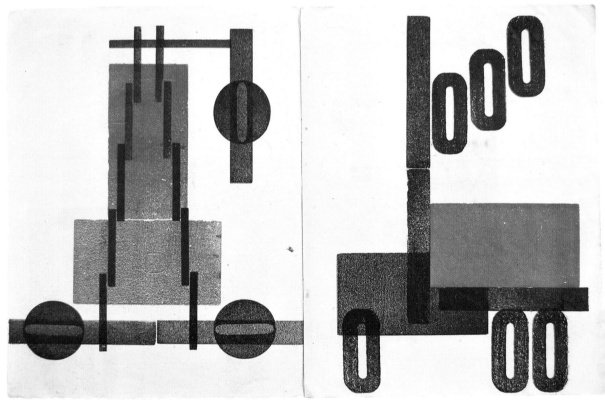

Per 1 September 1925

S E & O

Debet

Saldo: *boedelbeschrijving*

zwaarmoedigheid (in een rand van paars en groen)

Olympiade

zonde (nochtans met berouw)

prestatie: prestatie genegeerd

systeem: (navolgingsprincipe)

miserabel spel van geconfectioneer-de agitatie

redenaars (enkelvoudige praatautomaten)

baatzuchts- en bruikbaarheids-coëfficient (pro memorie)

toevalligheid (speculatief)

kas (in dank ontvangen)

Credit

consequentie

oefening in onver-schilligheid

verdrukking

blijmoedigheid

miskend zwijgen

standvastigheid

independence

half automatische cyclostyles en kasregisters

démasqué **en ijking**

vaststelling der misrekening

offers

The Next Call 8
Booklet
Text – H.N. Werkman
23 February 1926, 27·3 × 21·5 cm (10¾ × 8½ in)
8 pages inc. front & back, c. 40 copies

Following a playful industrial theme, the front depicts a factory, page 2 a machine with a pulley and the back a toy-like forklift. A "debit" and "credit" account on pages 4 and 5 parodies the sad state of Werkman's finances.

back & front [OPPOSITE TOP]
pages 2 & 3 [OPPOSITE BOTTOM]
pages 4 & 5 [LEFT]
pages 6 & 7 [BELOW]

45

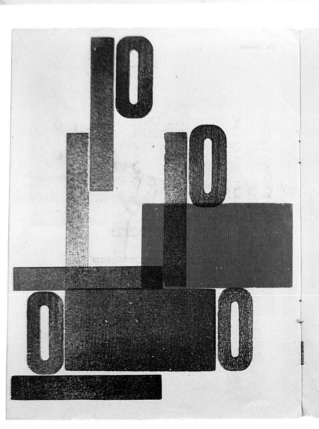

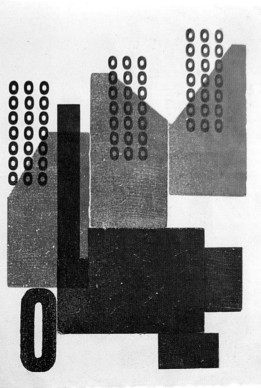

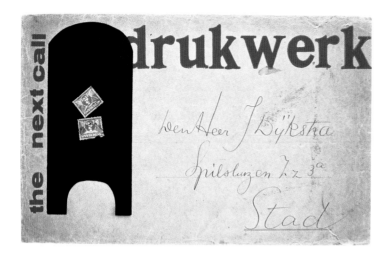

the next call / drukwerk

den Heer J Dijkstra
Spilsluizen Zz 3a
Stad

tekst

en

typografie

van h n

werkman

lage der a
13

groningen

(holland)

november

1926

the next call 11

9

The Next Call 9
Booklet
Text – H.N. Werkman
November 1926, 35×21·4cm (13¾×8½in)
8 pages inc. front & back, c. 40 copies

On the envelope for The Next Call 9,
"drukwerk" (printed material) dominates
the top and stamps are pasted on the form
of a mailbox on the left. As with The Next
Call 7, there are two variations of the cover.
This issue is dedicated to Lioubomir
Mitzitch, poet and publisher of the
magazine Zenith in Belgrade. With the
text in Dutch and German it is clear that
Werkman wanted The Next Call to be seen as
a world publication, though it was scarcely
perceived as such in his lifetime. The pages
conclude with Werkman's pensive poem:

once when the earth was still not round
once when art was still not art
once when the ant was not yet diligent
once when he was still young
once when she was still small
once when my mother still sang
once when it was summer
once when it was still the day before yesterday
once when yesterday was not yet today.

envelope [OPPOSITE TOP]
back & front [OPPOSITE BOTTOM]
pages 2 & 3 [BELOW]

The Next Call 9 (continued)
pages 4 & 5 [BELOW]
pages 6 & 7 [OPPOSITE]

48

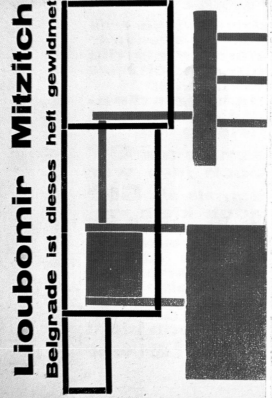

Lioubomir Mitzïtch

Belgrade ist dieses heft gewidmet

*damals als die erde
noch nicht rund war*
**damals als die
kunst noch** *keine*
kunst war
da*mals* **als die a-
meise** *noch* **nicht
fleiszig war**

*da*mals **als** er
noch *jung* war
damals *als* **sie**
noch klein *war*
damals als meine
mutter *noch sang*
dama*ls* **als es**
sommer *war*
damals als es noch
vorgestern war
*da***mals als ges-**
tern noch nicht
heute *war*

50

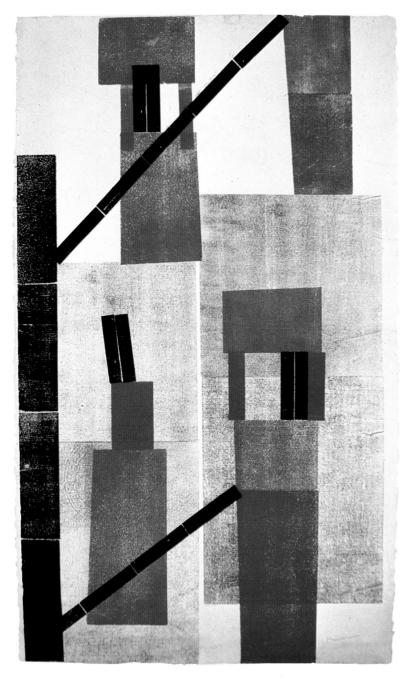

Schoorstenen 2 (Chimneys 2)
"Druksel" print
September–December 1923
70×43cm (27½×17in)
3 known copies

This is possibly one of the first of over 600 druksels, an abstraction based on a chimney. It is built up from layers of ink printed from the backs of wood type and printing furniture.

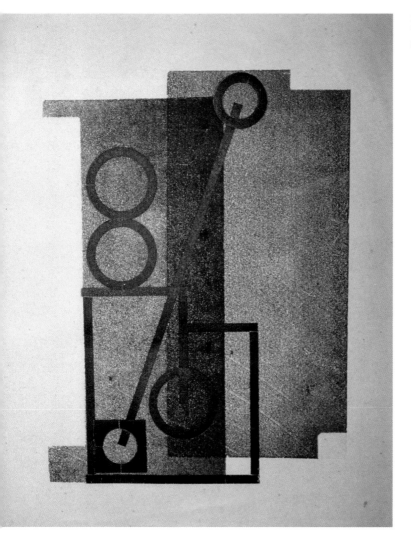

Kompositie (Composition)
"Druksel" print
c. 1925–26, 27·4 × 21·5 cm (10¾ × 8½ in)

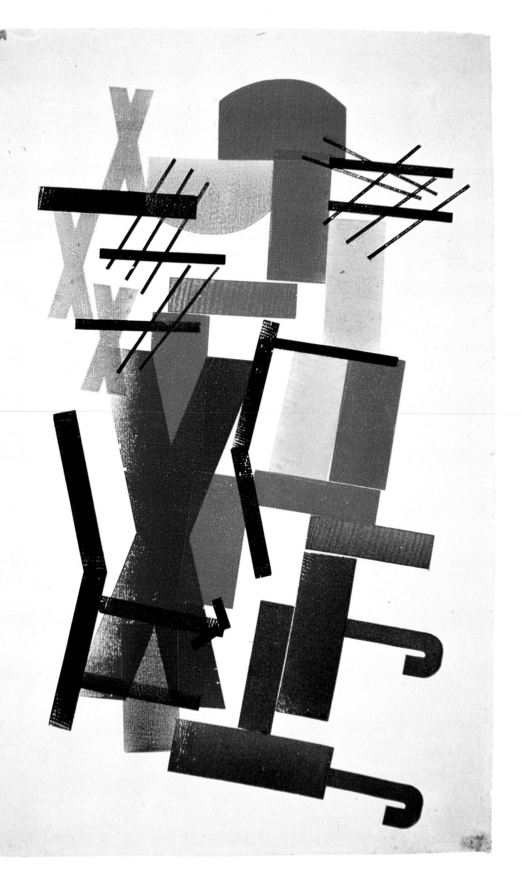

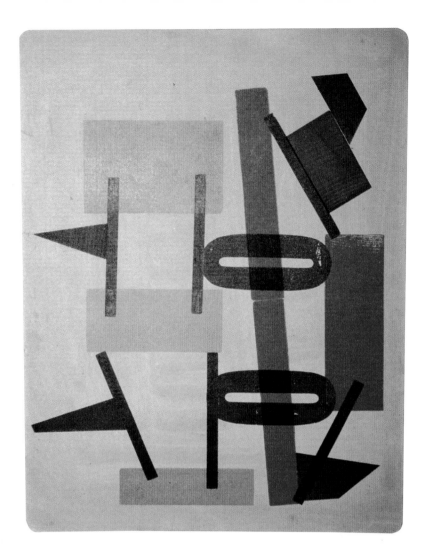

Kompositie met letters X
(Composition with Letter "X")
"Druksel" print
c. 1927, 45·8 × 29·7 cm (18 × 11⅝ in)
[OPPOSITE]

The irregular ink viscosity and printing
pressures create textures that contribute
to the painterly quality of the print.

Kompositie met letters O
(Composition with Letter "O")
"Druksel" print
c. 1927–28, 26 × 20·4 cm (10¼ × 8 in)
[ABOVE]

54

"Tiksels"
Drawings made with typewriter
c. 1923–29, 27 × 21 cm ($10^5/_8 × 8^1/_4$ in)

The tiksels were a brief diversion for
Werkman and were never exhibited or
published in his lifetime. Created on a
conventional typewriter, they exhibit a
remarkable control and harmony within
the confines of a restricted medium.

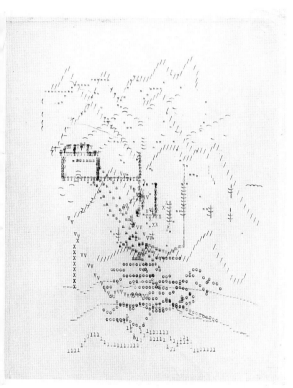

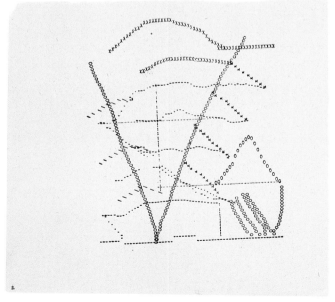

56 *De Ploeg in Pictura*
(De Ploeg in the Pictura Gallery)
Poster
April 1925, 92·3 × 40·6 cm (36³⁄₈ × 16 in)
[RIGHT]

This was one of many posters Werkman
designed for De Ploeg, reflecting both the
typography of *The Next Call* and the abstract
approach of the druksels. It serves as a
poster and a druksel simultaneously.

1926 calendar page
Publisher – De Ploeg
1925, 57 × 45 cm (22¹⁄₂ × 17¾ in)
[OPPOSITE]

This was Werkman's first known calendar
page. A collaborative effort by De Ploeg
members, the November contribution
was designed by Werkman and the other
months by De Ploeg artists Jan Altink,
Jan Jordens, Jan van der Zee, Johan
Dijkstra, Jan Wiegers, Jannes de Vries
and Henk Melgers.

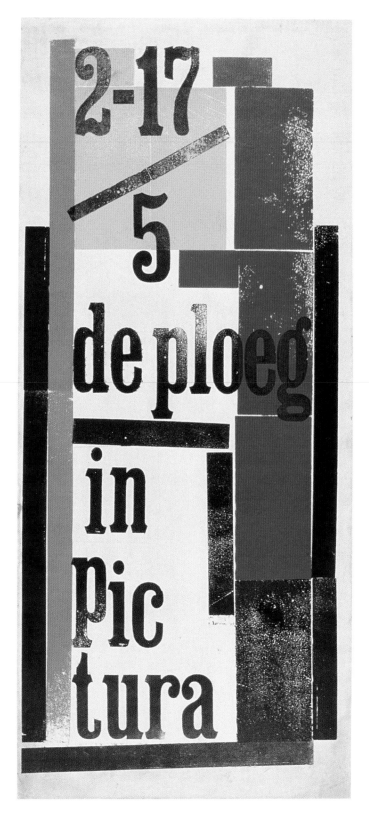

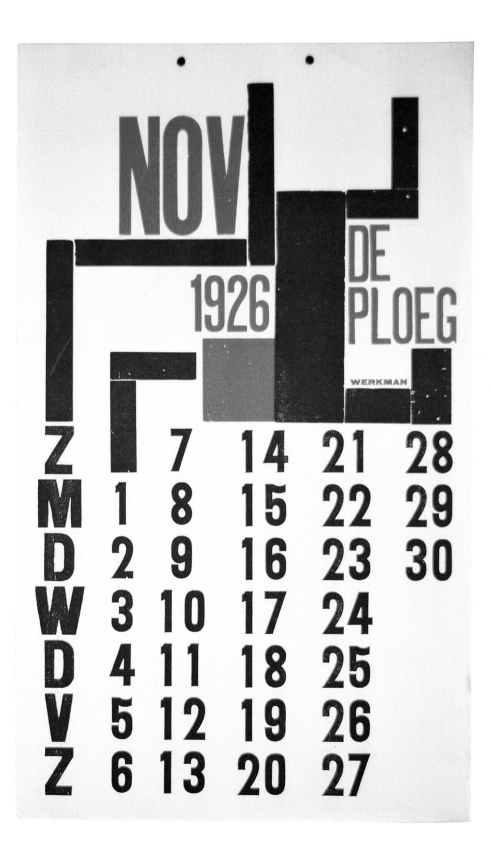

Invitation to a De Ploeg meeting
Publisher – De Ploeg
1926, 27·5 × 21·5 cm (10⁷⁄₈ × 8¹⁄₂ in)

In addition to posters, Werkman designed
invitations for De Ploeg. Here, the logo for
De Ploeg is turned into a flower with petals
made from type furniture.

Birth announcement card
15 December 1926
35·1 × 21·2 cm (13⁷⁄₈ × 8³⁄₈ in)

Werkman often produced birth
announcement cards such as this one
for Johannes Tjeerd Hansen, the son of
fellow De Ploeg member Job Hansen.

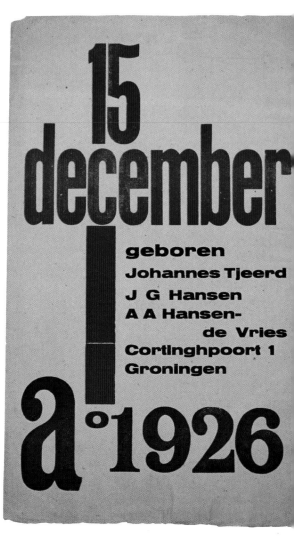

Invitation
Publisher – De Ploeg
19 June 1926, 36·4 × 19·9 cm (14⅜ × 7⅞ in)

The size of a small poster, this is an
invitation for artists to submit work
for an exhibition in Het Prinsenhof
(the Prinsenhof Gallery) in Groningen.
Werkman adapts the De Ploeg logo with
a semi-circle and extended rule along
the left side of the text.

59

Groninger Kunstkring „De Ploeg".

Het bestuur deelt U hierbij mede dat de
nieuwe benedenzalen in het Prinsenhof
thans gereed zijn en een schitterende
gelegenheid bieden tot het houden van
exposities. Er is ruimte voor 15 stukken
in de eene zaal en voor 20 in de andere.
U wordt verzocht te willen opgeven of U
in beide zalen, in een van de zalen alleen
of in combinatie met een of meer leden
naar Uwe afspraak werk wenscht tentoon
te stellen. Duur der exposities telkens
ongeveer drie weken. Verzend-, reclame-
en ophangkosten komen voor rekening
der exposanten, zaalwacht voor rekening
van De Ploeg, entrée's komen ten bate
der vereeniging. Redactie van advertenties
en reclame in overleg met het bestuur.
Opgave wordt verzocht voor 20 Juni a.s.
aan den secretaris, Lage der A 13, Gron.
In nader overleg worden daarna de data
der verschillende exposities vastgesteld.
19 Juni 1926. Het Bestuur.

Exposition du Congres, De Ploeg Prinsenhof
De Ploeg Exhibition du Congres in
the Prinsenhof Gallery)
Poster
Publisher – De Ploeg
September 1926
91·8×57·1 cm (36¹⁄₈×22¹⁄₂ in)
[OPPOSITE]

For this exhibition poster, a rectangular
shape forms a base for what appears to
be an abstract sculpture. *Le cercle d'art
de Groningue* (the Groningen art circle)
is emphasized by the setting of the type
in an arc.

Kalendar 1927 (Calendar 1927)
1926, 35·2×21·5 cm (13⁷⁄₈×9⁷⁄₈ in)
12 sheets
[RIGHT]

With overlapping rectangular blocks
of type furniture Werkman created a
druksel-inspired calendar, with each
sheet having its own variation. The sheet
for April is shown here.

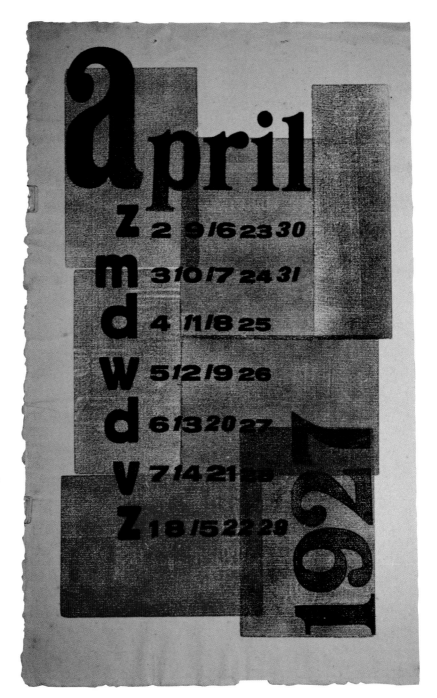

de ploeg

Groningen

Holland

1927

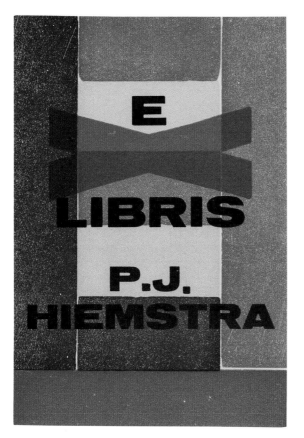

De Ploeg Groningen Holland 1927
Book
Publisher – De Ploeg
1927, 36·5 × 23·8 cm (14³⁄₈ × 9³⁄₈ in)
36 pages inc. front & back
[OPPOSITE]

The inside pages display some of
Werkman's few Constructivist-inspired
compositions. The text in German
expresses his views on the mission of
De Ploeg. Its more expressive cover, shown
here, belies the Constructivist content.

Ex-libris for P.J. Hiemstra
1923–28, 11·1 × 8 cm (4³⁄₈ × 3¹⁄₈ in)
[LEFT]

Proclamatie (Proclamation) 1
Manifesto
October 1932, 57·7 × 48 cm (22¾ × 18⅞ in)
[BELOW]

Beginning with the text "bij de opbouw
van een nieuw seizoen" (by the creating
of a new season), Werkman enumerates
his 36 artistic and spiritual goals for a
new *Next Call*.

Expositie (Exhibition)
Poster
Publisher – De Ploeg
September 1931
65·3 × 50·8 cm (25¾ × 20 in)
[OPPOSITE]

64

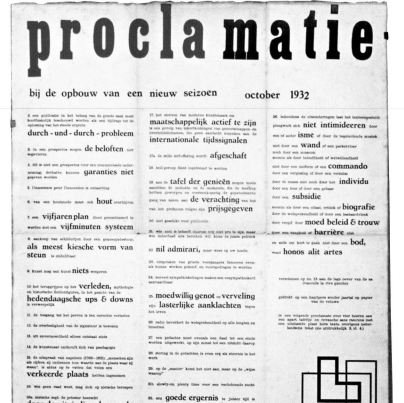

expositie

H. N. WERKMAN

Gron. Kunstkring
„DE PLOEG"
Tentoonstelling
20 Sept. – 11 Oct. '31
i.d. Picturazalen

gron. stud. tooneelgezelschap
neemt ons zooals we zijn

de rekenmachine

elmer l. rice

31
maart
8
uur

prijzen der
plaatsen

2.50

1.75

1.25

0.75

stadsschouwburg

alles inbegrepen behalve plaatsbespreken

De rekenmachine (The Adding Machine)
Poster
Publisher – Stadsschouwburg
March 1933, 64·8×50·5cm (25½×19⅞in)
[OPPOSITE]

In this poster for a play by the progressive American playwright Elmer L. Rice, a calculator is constructed from typographic elements. After World War II, Rice saw the poster for the first time at a Werkman exhibition at the Stedelijk Museum in Amsterdam.

Kompositie met letters en cijphers
"Druksel" print
(Composition with Letters and Numbers)
1929–34, 17·8×11·3cm (7×4½in)
[BELOW LEFT]

Part of a series of four, this letter-based composition displays a carefully controlled, almost sculptural, sense of balance.

Catalogus Jubileumtentoonstelling "De Ploeg"
(Catalogue: De Ploeg Jubilee Exhibition)
Booklet
February 1933, 24·4×15cm (9⅝×6in)
12 pages inc. front & back
[BELOW RIGHT]

Kompositie met architectonische elementen
(Composition with Architectural Elements)
'Druksel" print
1929, 63 × 50 cm (24$^7_8$ × 19$^5_8$ in)
[OPPOSITE]

In 1929, Werkman began to use an
ink roller, stencils and freely stamped
elements in the druksels. Both non-
objective and image-based, the new
druksels became more expressive and
this approach was closer to that of
painting. In this piece, windows are
implied through stamping en- and em-
spaces on the surfaces of the larger shapes.

Kompositie (Composition)
'Druksel" print
1929, 63 × 50 cm (24$^7_8$ × 19$^5_8$ in)
[RIGHT]

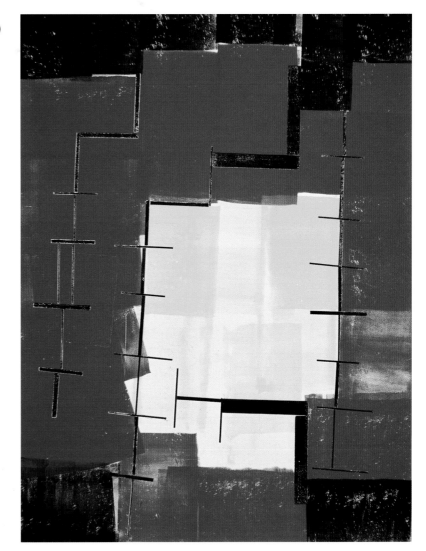

Kompositie met letters g en l
(Composition with Letters "g" and "l")
"Druksel" print
1929–34, 63·2×48·4 cm (24⁷₈×19in)

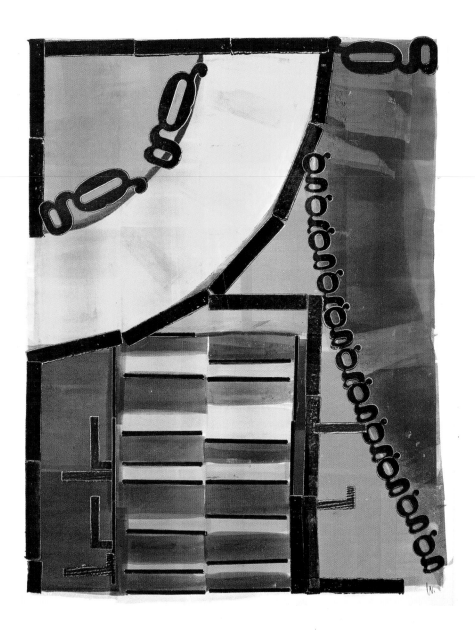

Bloementafel (Flower Table)
"Druksel" print
1938–39, 65×50 cm (25¹⁄₂×19⁵⁄₈ in)

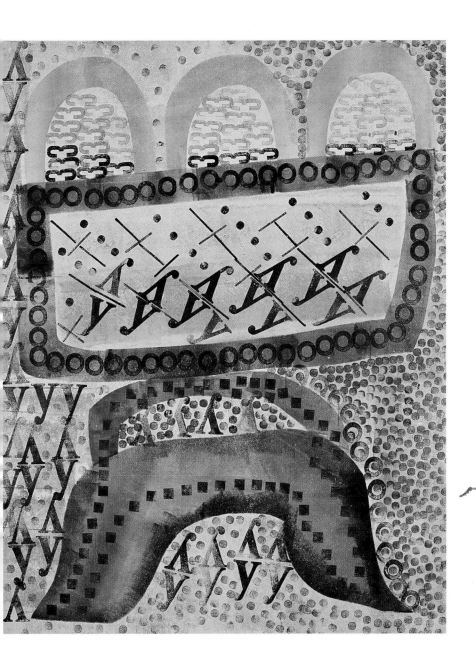

Tentoonstelling
DE PLOEG
in de zalen van
PICTURA
12 - 26 September

entoonstelling *De Ploeg in de zalen van Pictura*
(De Ploeg exhibition in the halls of the
Pictura gallery)
Poster
Publisher – De Ploeg
September 1937
64·8×50cm (25$^1$$_2$×19$^5$$_8$in)
[OPPOSITE]

In this later poster for De Ploeg, Werkman
produces an image of a woman using
stencils, stamps and the edge of an ink
roller as a drawing instrument.

Preludium
Booklet
September 1938, 23·3×15·3cm (9×6in)
20 pages inc. front & back
[RIGHT]

Written, printed and illustrated by
Werkman, *Preludium* appeared in
September 1938. The type on the cover,
shown here, takes on the shape of an
accordion and the images are produced
using stencils and woodcuts. *Preludium* was
sent to De Ploeg members in response to a
booklet written by De Vries and Dijkstra,
De Ploeg, 20 Jaar (De Ploeg, 20 Years), which
advocated the acceptance of twelve new
members whom the uncompromising
Werkman considered too bourgeois.
When these individuals were eventually
admitted, some of the more progressive
members resigned, but Werkman
remained active.

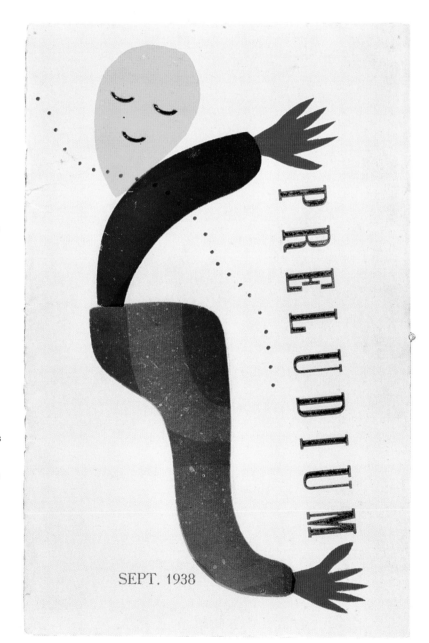

74

Echo
Text – H.N. Werkman
1938, 30·5×24·5cm (12×9⅝in)
Folded sheet

Echo was one of Werkman's manifestos, an "attempt to break the silence" and encourage De Ploeg members to speak their own minds. The simple typographic front expresses the meaning of the word "echo" through a repetition of colour.

Protocol
Publication
1929–39, 29·1 × 24·2 cm (11½ × 9½ in)
Folded sheet

This striking cover design for *Protocol* was never used, since Werkman left the publication unfinished.

Der Mai ist da (May Has Come)
Book
c. 1930–35, 24 × 16·3 cm (9½ × 6½ in)
104 pages inc. front & back, single copy

Der Mai ist da is puzzling because only one copy is known to exist. The front (shown here) and the 48 drawings inside are by Werkman. The two poems are also assumed to be his. Although dated c. 1930–35 in the 1977 Stedelijk Museum catalogue, the refined style of the piece suggests a later publication.

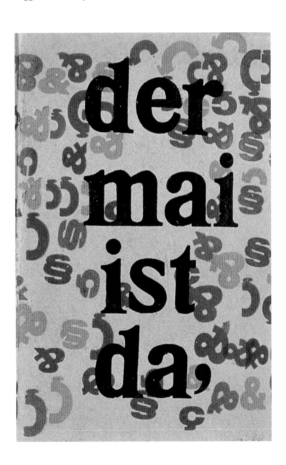

Alleluia
Booklet
Publisher – De Blauwe Schuit
De Blauwe Schuit 3, April 1941
24·9×19·1 cm (9⁷₈×7¹₂ in)
8 pages inc. front & back, 60 copies

The graceful and melodic typography that
Werkman uses for *Alleluia*, an old Dutch
Easter hymn, visually recalls pages 4 and 5
from *The Next Call 9*.

page 3 [LEFT]
pages 4 & 5 [RIGHT]

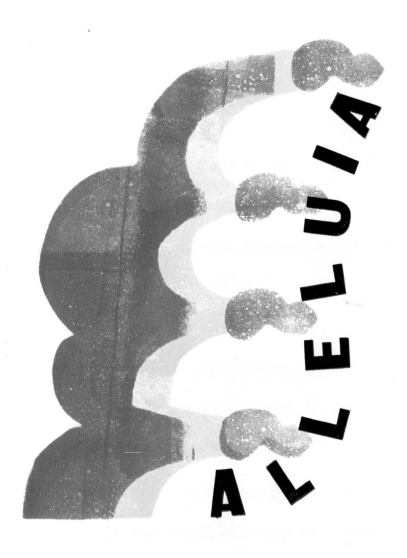

A,

de blijde toon,

gen zoet en schoon.

a, alleluia.

ga,

lleluia,

ia!

ALLELUIA,

a, alleluia.

g,

alleluia,

oorzag.

, alleluia, alleluia.

Want onze Heer en Koning groot
alleluia,
is nu verrezen uit den dood.
alleluia,
alleluia, alleluia, alleluia.

Die stervend ons het leven gaf,
alleluia,
verrees in glorie uit het graf.
ALLELUIA,
alleluia, alleluia, alleluia.

Of nu de satan raast en tiert,
alleluia,
de Leeuw uit Juda zegeviert.
ALLELUIA,

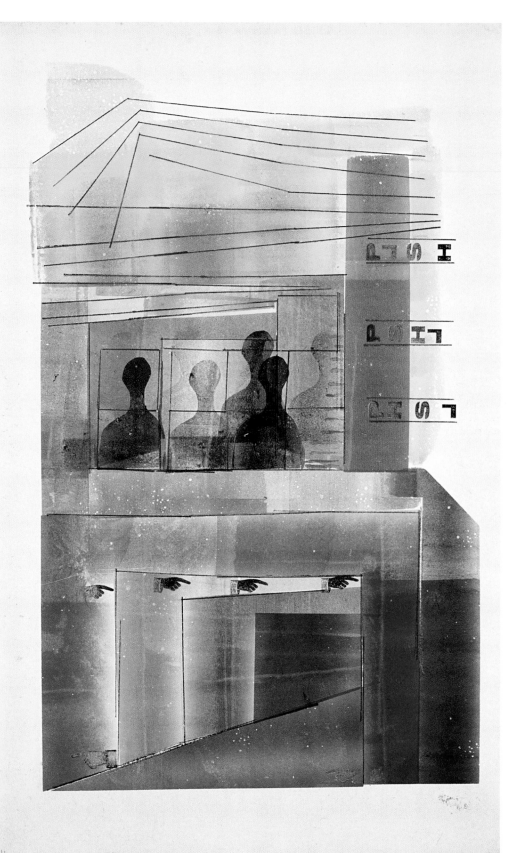

...nsterdam-Castricum 3
...Druksel" print
...41, 51×32·8cm (20×13in)
...PPOSITE]

...his is from an eleven-print series inspired
...y Werkman's visit with Willem Sandberg
...nd Jan Wiegers to Castricum where
...aintings from the Stedelijk Museum were
...idden during World War II. This series
...egan Werkman's most productive
...ruksel period.

...rière, gedicht van Charles Péguy
...Prayer, poem by Charles Péguy)
...ooklet
...ublisher – De Blauwe Schuit
...e Blauwe Schuit 5, April 1941
...·6×15·1cm (8×6in)
...pages inc. front & back, 90 copies
...IGHT]

...he design of the cover, which includes
...e first line of the poem, was later used
...y Dutch designer Jan Bons as a motif for
...stamp that commemorated the liberation
...1945.

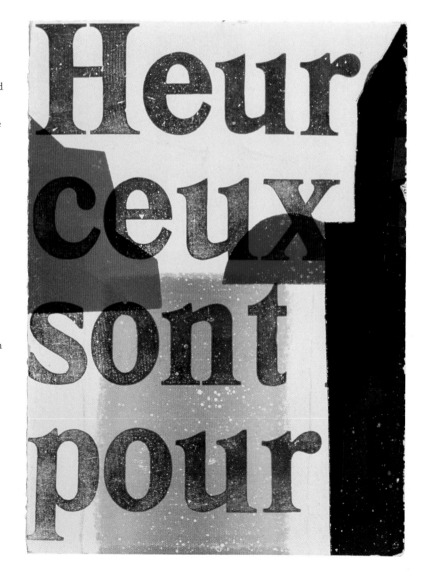

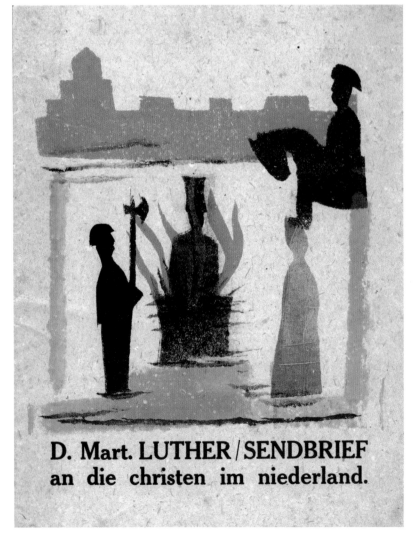

D. Mart. LUTHER / SENDBRIEF
an die christen im niederland.

Sendbrief an die christen im niederland
(Epistle to the Christians in the
Netherlands)
Booklet
Publisher – De Blauwe Schuit
Text – Martin Luther
De Blauwe Schuit 6, May 1941
18·8 × 14·5 cm (7¹⁄₂ × 5¾ in)
8 pages inc. front & back, 90 copies

This epistle was one of three texts by
Martin Luther published in *De Blauwe
Schuit*. The front, shown here, is printed
on packing paper using stencils and the
ink roller as a painting tool, alongside
conventional typography.

Een moscovitische legende
(A Muscovite Legend)
Booklet
Publisher – De Blauwe Schuit
Text derived from Vladimir Solovjev's
Legend of the Anti-Christ
De Blauwe Schuit 7, May 1941
29 × 22 cm (11¹⁄₂ × 8⁵⁄₈ in)
16 pages inc. front & back, 120 copies

Een moscovitische legende, pages 2 and 3
of which are shown here, was seditious
both in name and in its generous use of
the colour red.

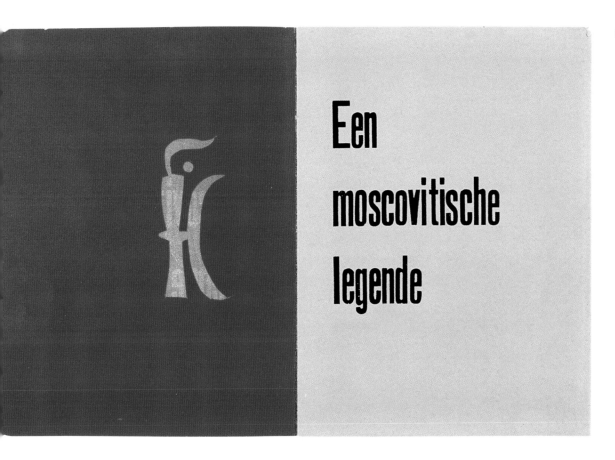

Een
moscovitische
legende

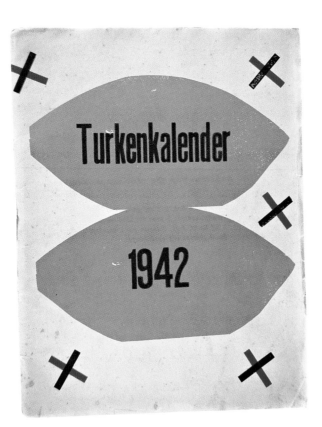

Turkenkalender 1942
(Turkish Calendar 1942)
Publisher – De Blauwe Schuit
De Blauwe Schuit 8
September–December 1941
32·7 × 25 cm (12⅞ × 9⅞ in)
32 pages inc. front & back, c. 120 copies

Selected by local school teacher and
Blauwe Schuit "skipper" Adri Buning, most
of the fifteen texts in the *Turkenkalender*
were resistance songs from the period of
the Dutch struggle against Spanish rule
in the 17th century. All of Werkman's
previous techniques are brought into play
and he darkly joked that having broken
all maxims of the printing trade his life
would no doubt be in danger from
outraged typographers.

front [LEFT]
June [BELOW]
July [OPPOSITE TOP]
September [OPPOSITE BOTTOM]

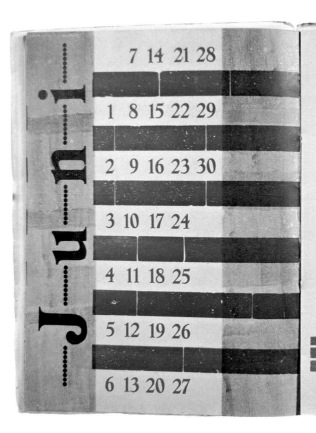

De Staten-Generael der Geunieerde Nederlanden, allen dengenen die dese sullen sien ofte hooren lesen, Saluyt.

Alsoo een yegelick kennelick is, dat een Prince van den Lande van Gode ghesteldt is Hooft over sijne Ondersaten, om deselve te bewaren ende beschermen van alle ongelijck, overlast ende geweldt, gelijck een Herder tot bewarenisse van sijn Schapen: Ende dat d' Ondersaten niet en sijn van Gode geschapen tot behoef van den Prince, om hem in alles wat hij beveelt, weder het goddelick oft ongoddelick, recht ofte onrecht is, onderdanich te wesen ende als slaeven te dienen; maer den Prince om d' Ondersaten wille, sonder dewelcke hij gheen Prince en is, om deselve met recht ende redenen te regeeren, voor te staen ende lief te hebben als een Vader sijne Kinderen, ende een Herder sijne Schapen, die sijn lijf ende leven setter om deselve te bewaren. Ende soo, wanneer hij sulcx niet en doet, maer in stede sijne Ondersaten te beschermen, deselve soeckt te verdrucken, t' overlasten, heure oude vrijheijt, Privilegien ende oude herkomen te benemen, ende heur gebieden ende gebruijcken als slaven, moet ghehouden worden niet als een Prince, maer als een Tyran ende voor sulcx nae recht ende reden mach ten minste van syne Ondersaten, besonder bij deliberatie vande Staten vanden Lande, voor geen Prince meer bekent, maer verlaten, ende een ander in sijn stede tot beschermenisse van henlieden, voor over-hooft, sonder misbruycken, gekosen werden. Te meer so wanneer d' Ondersaten met ootmoedige verthooningen niet en hebben heuren voorsz. Prince konnen vermorwen, noch van sijn tyrannigh opset gekeeren, ende alsoo geen ander middel en hebben om heure eygenen, heurer Huyss-vrouwen, Kinderen ende Nakomelingen aengheboren vrijheijt (daer sij nae de Wet der Natueren goet ende bloedt schuldigh sijn voor op te setten) ende beschermen

't Welck principalick in dese voorsz. Landen behoort plaetse te hebben en stant te grijpen, die van allen tijden sijn geregeert geweest, ende hebben oock moeten geregert worden, naevolgende den Eedt bij heure Princen 't heuren aenkomen gedaen, na uytwijsen heurer Privilegien, Costuymen ende oude herkomen: hebbende oock meest alle de voorsz. Landen haren heere ontfangen op Conditie, Contracten ende Accoorden, de welcke brekende, oock naer recht den Prince vande heerschappije vanden Landen is vervallen. . . .

Uit het Plakkaat van verlating
van 26 Juli 1581.

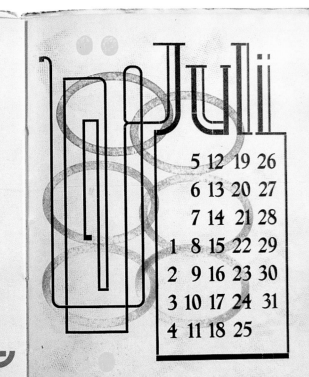

The Juli calendar:
5 12 19 26
6 13 20 27
7 14 21 28
1 8 15 22 29
2 9 16 23 30
3 10 17 24 31
4 11 18 25

Onweder

Och lighdy Heer en slaept
In dese sware stonde?
Terwijl ghy ruste raept
So sincken wij te gronde.

Wij wellen in het sant,
Wij stoten op de clippen,
Ons takels en ons want
Begint ons te ontslippen.

Het schrickelijck gewaey
Ons over-stuyr doet drijven,
Den mael-stroom met een draey
Ons dreyget te ontlijven.

Wij sien noch sterr' noch maen,
't Compas begint te wraken,
Het roer wil ons ontgaen,
De steven is aen 't craken.

Den roover is aen boort,
Den vijant op de luycken,
De boech is doorgeboort,
De kiel begint te duycken.

Het seyl leyt voor de mast,
Het ancker aen 't slepen,
Help Heer! wij lijden last!
Help Heer! wij sijn gegrepen!

Nu mannen, goeden moet!
Den slaper is gewecket,
Hij scheidt de swarte vloet,
Den hemel hij ontdecket.

Den vyant neemt de vlucht,
O, wonder over wonder!
Gestilet is 't gerucht
Van hagel en van donder.

Het roer hij selver vat,
Hij kijvet met de winden,
Ja, doetse liggen plat
En schiedelijck verswinden.

Hij straft die weecke maets,
Die haer niet cloeck en dragen
En voor een weynich quaets
So lichtelijck vertsagen.

O wat zijt ghij een Godt,
Die stormen ende baren
Bevreest voor u gebot
So machtich weet te claren!

Ghij calmt de stuyre zee,
En brengt die u geloven,
Op een behouden rêe
Daer sij u eeuwich loven.

Jacob Revius

SEPTEMBER

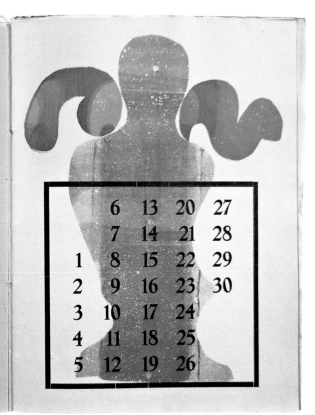

Second calendar:
 6 13 20 27
 7 14 21 28
1 8 15 22 29
2 9 16 23 30
3 10 17 24
4 11 18 25
5 12 19 26

Een nieuw liedeken.

Op de wijse: Swinters Somers even groen,
al waer de Staten van Brabant ende Vlaande-
ren troosten die van Hollant ende Zeelant.

O Hollant en Zeelant cloeckmoedich
Waarom treur dy in desen tijt?
Want Godt die sal noch seer voorspoedich
Verstercken u daden gebenedijt!
Dus treurt niet, lieve metgenooten
Want ghy sult sien aen elcken cant
Dat uyt u wercken sijn ghesproten
Vrijheyt in ons vaders lant.

Hout op van claghen, vrienden fiere
En toont u cloeck in u voorstel
So ghy ghedaen hebt goedertiere,
Al sien u vijanden noch so fel:
Sij hebben u noch niet verbeten,
Al toonen sij haer so vaillant,
Want wij wenschen ooc, wilt dit weten,
Vrijheyt in ons vaders lant.

Strijdt ghy dan voor Gods woort warachtich,
So strijden wij noch eer yet lanck
Met al het ghantsche lant eendrachtich,
Om te leven vrij ende vranc:
Uyt het ghewelt der Spaensche honden,
Die ons duslange hebben vermant;
En vercrijghen so tot aller stonden,
Vrijheyt in ons vaders lant.

September 1576.

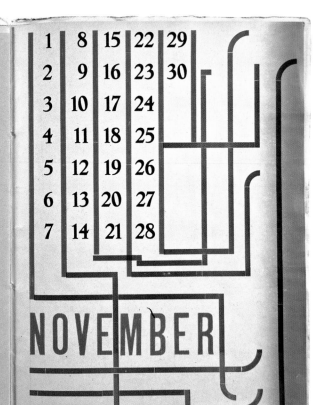

1	8	15	22	29
2	9	16	23	30
3	10	17	24	
4	11	18	25	
5	12	19	26	
6	13	20	27	
7	14	21	28	

NOVEMBER

Schijn voor Zijn

Lijdelijker is 't en nutter,
 dat men altijd zotheyd schrijft,
Dan zijn penne wijs laat wezen,
 als men zelfs nog onwijs blijft.
Waar is sterker tegen-tuyge
 en meer leerings hindernis,
Dan daar òf gemoed òf werken
 roepen, dat 't et leugen is?
Grond bij mond. En daad bij praat.
 Want waar men anders doet dan zeyt,
Word de Waarheid schelmsch verraden
 van den man, wiens tong haar vleyt;
Vruchtloos preekt men van de Deugde,
 zoo lang 't leven tegen preekt;
Uyt en In moet eenig wezen:
 Schijn voor Zijn bouwt niet, maar breekt.

Dirck Raphaelsz. Camphuyzen

Colophon

De eerste Turkenkalender is van
Johannes Gutenberg, en werd
gedrukt te Mainz in de maand
December van het jaar 1454.
Deze, de tweede van dien naam,
werd in opdracht van De Blauwe
Schuit gedrukt in het late najaar
van 1941 door H. N. Werkman op
zijn handpers, en verscheen tus-
schen Kerstmis en Nieuwjaar.
Er werden 120 exemplaren ge-
drukt alleen voor de vrienden
van De Blauwe Schuit.

Turkenkalender (continued)
November [OPPOSITE TOP]
pages 30 & 31 [OPPOSITE BOTTOM]

Gesprek (Conversation)
Booklet
Publisher – De Blauwe Schuit
Text – F.R.A. Henkels
De Blauwe Schuit 9, March 1942
31·7 × 22·2 cm (12$^1$⁄$_2$ × 8$^3$⁄$_4$ in)
8 pages inc. front & back, 120 copies

Gesprek is a description by Henkels of a
1938 painting by Werkman of the same
title. On page 3 is an inside cover showing
four pawn-like shapes created with stencils
and implying different speakers. On pages
4 and 5, each conversationalist is indicated
by a different colour.

page 3 [RIGHT]
pages 4 & 5 [BELOW]

85

De schilder ging door de straten. Hij was alleen. Iedereen was alleen. De takken der boomen stonden kaal en doornig tegen de grauwe lucht, het was Goede Vrijdag. De schilder was alleen, toen begon de stem het Gesprek. Hij ging naar huis, nam het linnen, de verf en de penseelen. Hij schilderde het Gesprek, dat begonnen was door de stem. Hij was niet meer alleen. Het Gesprek was er.

Hij schilderde. Hij nam het paars van vele angstige nachten, een vochtig zwart en uit een oud wiegelied het teedere geel. En dit werd de eerste gestalte van de vier, die het wondere gesprek voeren dat door de stem is begonnen. Deze is de man die het hoofd achterover gebogen houdt en de linkerhand opgeheven. Hij spreekt, maar zijn stem zoekt aarzelend nog den weg uit de donkere grotten der laatste ontzetting. En nog ligt de paarse weerschijn van den nacht over het gelaat en in zijn stem klinkt de stilte van een hof waarin alleen de kleine nachtwind is gebleven. Is de eerste kreet der hanen zoo nabij? Zijn oogen tranen, dat komt door den rook van het vuur waar hij vlak bij zit. Dan staat hij tegen een muur geleund en deze muur is het einde der wereld. Hij spreekt, zijn kroezig zwarte haar hangt achterover, het lijkt alsof het nog nat is van zweet. Maar zijn gewaad is roomkleurig en zoo zacht als de vacht van schapen. Sla de wolven herder, en ontsteek de morgenster in het hart van een nieuw volk!

Toen nam de schilder het rood, een onverzettelijk rood. En uit dit rood ontstond de man met den bont en groen geschakeerden mantel, als een uitgespreide kaart met vele zeeën en eilanden daarin. Hij draagt het hoofd recht als een kaars. Soms is de kaars uitgedoofd, soms draagt ze de vlam. Maar recht is de kaars en zoo is deze man in dit gesprek. Zijn oog is wijd open en hij wil zien, alles zien. Daarom is hij de diepste droomer van allen. Hij spreekt, onverzettelijk. Het kan het betoog zijn van den laatsten griekschen wijsgeer, van den eersten alexandrijn, van een parijsch scholast. Draagt ook niet Münzer, de donkere en toornige man uit den boerenkrijg, zijn europeesche naam? Hij betoogt, onverzettelijk. Maar eenmaal zal hij de hand, die nu opgeheven is tot het betoog, leggen in de teekenen van spijkers en speer. Dan zal hij volkomen wakker zijn.

Zij spreken, maar één er is die luistert. Voor hem heeft de schilder het geel genomen, een verzonken geel en het metaalblauw van een bergmeer. De anderen spreken, maar hij luistert en ziet voor zich. Zijn voorhoofd is hoog en peinzend, de handen heeft hij gevouwen. Hij wacht, als in voorbereiding, totdat hij spreken zal tot vele geslachten. Want hij die de handen gevouwen heeft bewaart het lied, het groote magnificat, der dienstmaagd des Heeren. Hij weet de tijdrekening van keizers en stadhouders en den weg die door hun wereld heenleidt naar een stal. Hij zal een heelmeester zijn voor alle menschen. En dan zal hij, die nu zwijgt, tenslotte de de pen opnemen en beschrijven hoe dit gesprek is begonnen tusschen Jeruzalem en Rome en niet zal eindigen tot dat de stem langs alle hemelen zal ruischen en iedereen zwijgt, zooals hij nu zwijgt en luistert, de handen gevouwen.

De schilder weet niet meer welke verven hij genomen heeft voor den vierden man. Want deze spreekt niet en zwijgt niet, zijn wijde armgebaar omvat de anderen en houdt ze bijeen. Komt dat omdat hij het naast aan het hart heeft gelegen van de stem? Kinderkens, het is de laatste ure. Zijn gezicht straalt van vreugde, want de hovenier is gekomen in zijn hof. Ziet wat deze liefde doet . . .

Morgenwit staat het schilderij tegen de wand en de schilder veegt aan het raam zijn penseelen af. Het is Goede Vrijdag geweest en Paschen geworden, één dag.

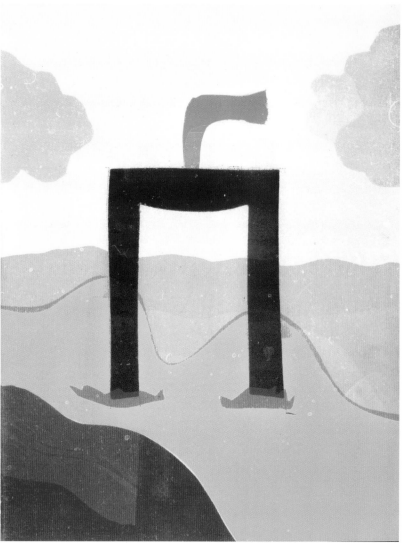

Bij het graf van den onbekenden
Nederlandschen soldaat (At the Grave
of the Unknown Dutch soldier)
Booklet
Poem by M. Nijhoff
Publisher – De Blauwe Schuit
De Blauwe Schuit 10, May 1942
24·3 × 18·7 cm (9$\frac{1}{2}$ × 7$\frac{3}{8}$ in)
8 pages inc. front & back, c. 200 copies
[LEFT]

The front, which shows a rectangular
portal implanted in a landscape, is created
from stencils.

Das Windliecht Gottes
(God's Storm Lantern)
Booklet
Publisher – De Blauwe Schuit
Fragments from a sermon
by Martin Luther
De Blauwe Schuit 11, May 1942
27·8 × 20 cm (11 × 7$\frac{7}{8}$ in)
8 pages inc. front & back, c. 200 copies
[OPPOSITE]

The text is taken from Martin Luther.
However, some readers thought it was
written by a contemporary writer using
the pen name "Luther". Created with
stencils and an ink roller, the front shows
Noah's ark floating on a rain-swept sea.

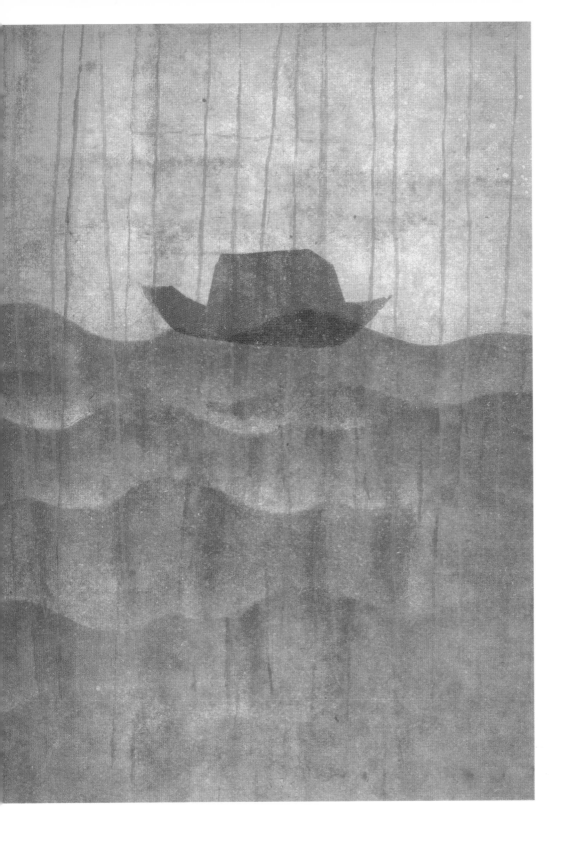

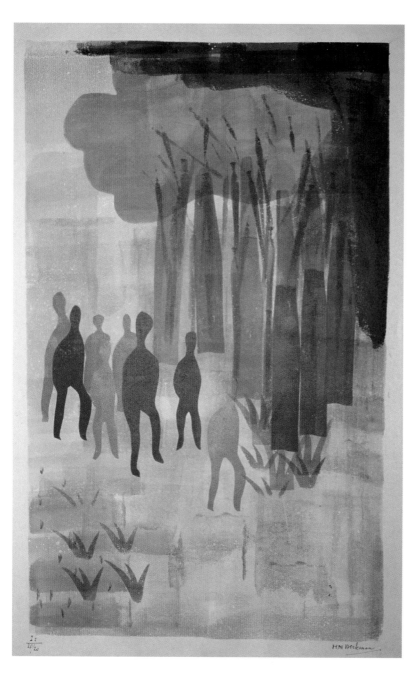

Chassidische legenden (Hasidic Legends)
First suite of 10 prints based on texts
from the legends of Martin Buber
with a commentary and introduction
to Hasidism by F.R.A. Henkels
Publisher – De Blauwe Schuit
De Blauwe Schuit 14
July, August & October 1942
49 × 33·1 cm (19¼ × 13in), 20 sets

It took Werkman two and a half years
to complete the series of 20 prints that
comprised the *Chassidische legenden*.
Martin Buber visited the Netherlands
two years after the war ended. When
Henkels showed him Werkman's series
Buber was astonished and asked Henkels
whether Werkman was Jewish. To Buber,
only a Jew could have interpreted the
tales so accurately.

number 1, *"De kinderen in het bosch" uit
het eerste deel van het verhaal: "De weerwolf"*
("The Children in the Woods" from the
first part of the story "The Werewolf")

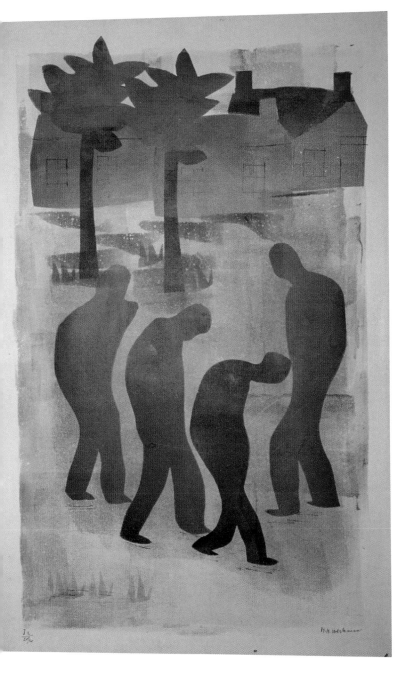

number 2, *"Vaders en zonen" uit het*
tweede deel van het verhaal: "De weerwolf"
("Fathers and Sons" from the second
part of the story "The Werewolf")

89

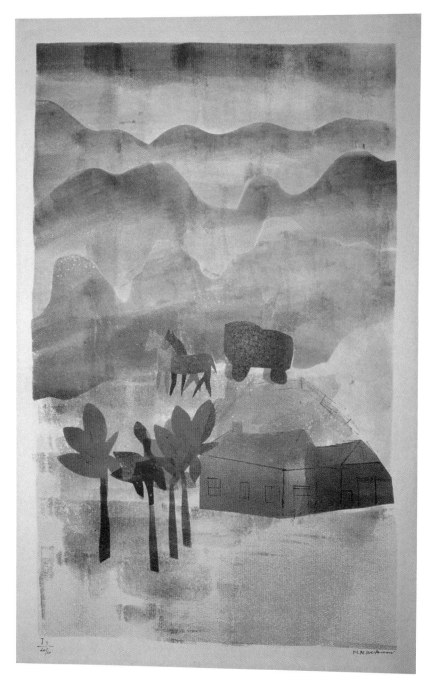

number 3, *"De herberg in de Karpathen" uit het eerste deel van het verhaal: "De openbaring"* ("The Inn in the Carpathians" from the first part of the story "The Revelation")

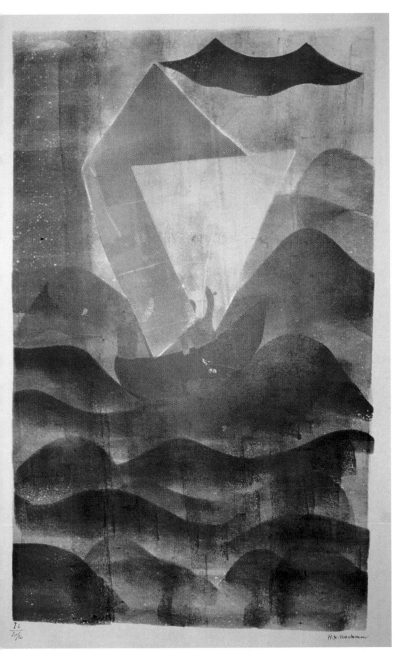

number 6, *"De tocht naar Jeruzalem"* 91
uit het eerste deel van het verhaal: "Jeruzalem"
("The Journey to Jerusalem" from the
first part of the story "Jerusalem")

92

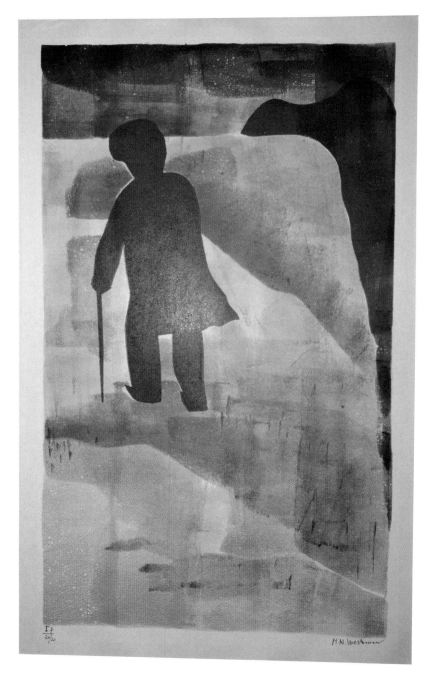

number 7, *"De weg terug" uit het*
tweede deel van het verhaal: "Jeruzalem"
("The Way Back" from the second part
of the story "Jerusalem")

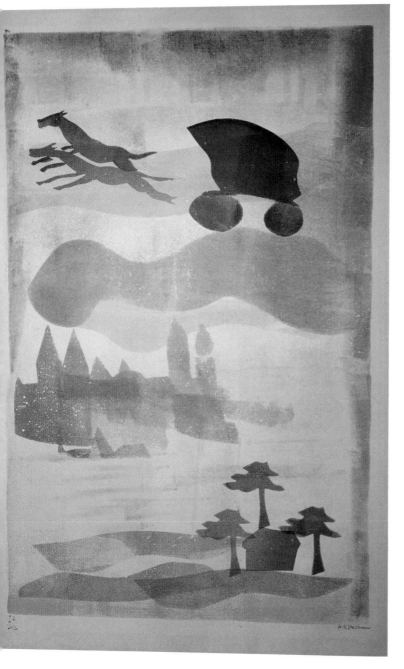

number 8, *"De rit naar Berlijn" uit het*
eerste deel van het verhaal: "De rechtspraak"
("The Ride to Berlin" from the first part
of the story "The Judgement")

Ascensus ad inferos (Ascent beneath)
Booklet
Publisher – De Blauwe Schuit
Poems – S. Vestdijk & F.R.A. Henkels
Introduction – F.R.A. Henkels
De Blauwe Schuit 17, November 1942
23·4×18·7cm (9¼×7⅞in)
8 pages inc. front & back, 50 copies

front [BELOW]
pages 2 & 3 [RIGHT]

Ascensus ad inferos includes poems by
S. Vestdijk and Henkels with Werkman's
illustrations made with stencils and an
ink roller. Due to the shortage of paper,
the text was printed on the pages of an
old ledger, although this was consistent
with Werkman's love of collage and
serendipity.

Gedichtje van Sint Niklaas
(Little poem of St. Nicholas)
Booklet
Poem – Paul van Ostayen
De Blauwe Schuit 19, November 1942
32·5×25·8cm (12¾×10⅛in)
8 pages inc. front & back, 20 copies

Gedichtje van Sint Niklaas, pages 2 and 3
of which are shown here, was printed in
November to bring some cheer to children
on 5 December, *Sinterklaasavond* (Saint
Nicholas' Eve).

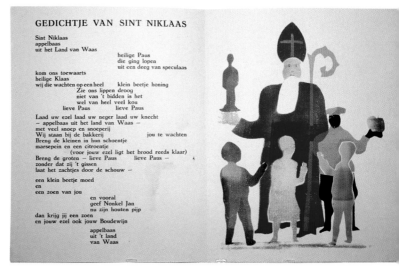

Paul Robeson zingt (Paul Robeson Sings)
Poem – H. Marsman
Publisher – De Blauwe Schuit
De Blauwe Schuit 22, December 1942
Folded sheet, 24·8×16cm (9¾×6¼in)

Paul Robeson zingt was seditious through
the choice of subject matter. Robeson
was especially hated by the Nazis because
of his support for the USSR and because
he was a black American.

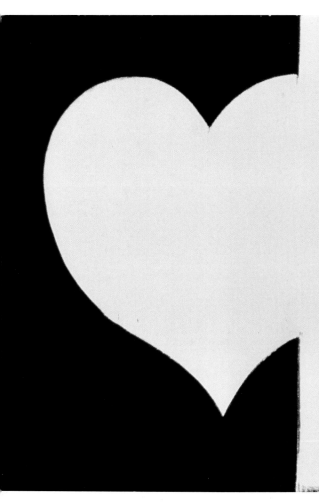

Paul Robeson zingt

(vier stemmen en de stem van Christus)

mijn hart is zwart
mijn hart is rood
mijn hart is hard
mijn hart is dood

 maar ieder hart

mijn hart is dood!

 maar ieder hart

mijn hart is rood . . .

 maar ieder hart
 't zij hard of dood
 of zwart of rood
 wordt wit in mijnen dood.

Colophon

Dit gedicht van H. Marsman werd op Kerstmis door een der schippers gezonden aan zijn
vriend in gevangenschap. Het werd gedrukt en versierd in de donkere dagen voor Kerstmis
1942 door H. N. Werkman in een oplage van 20 ex. Hiervan zijn enkele beschikbaar
voor vrienden van De Blauwe Schuit.

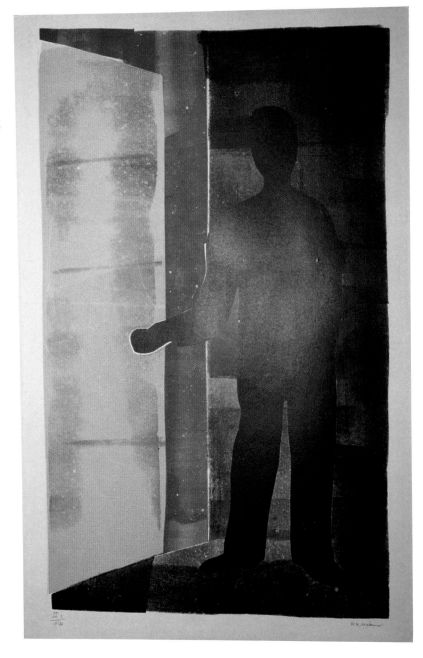

Chassidische legenden (Hasidic Legends)
Second suite of 10 prints based on texts
from the legends of Martin Buber,
preceded by *De legende van de zolder*
(The Legend of the Attic) by F.R.A. Henkels
Publisher – De Blauwe Schuit
De Blauwe Schuit 14
November–December 1943
50·6×32·8cm (20×13in), 20 sets

number 3, *"Het feest der vergeving" uit het
tweede deel van het verhaal: De "psalmenzegger"*
("The Feast of Forgiveness" from the
second part of the story "Psalm-Singer")

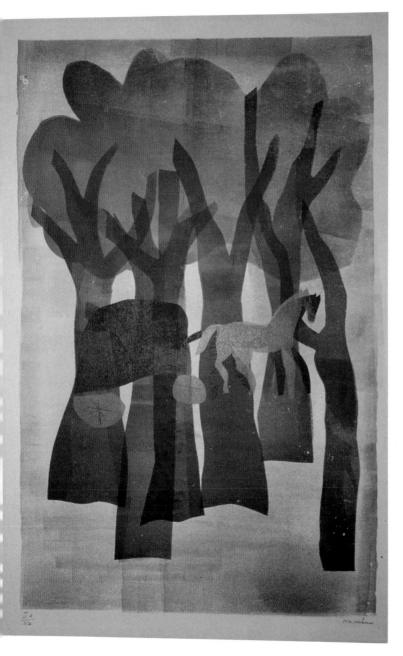

number 4, *"De wagon in het bosch"*
uit het eerste deel van het verhaal: "De
verstoorde sabbat" ("The Carriage in the
Woods" from the first part of the story
"The Disturbed Sabbath")

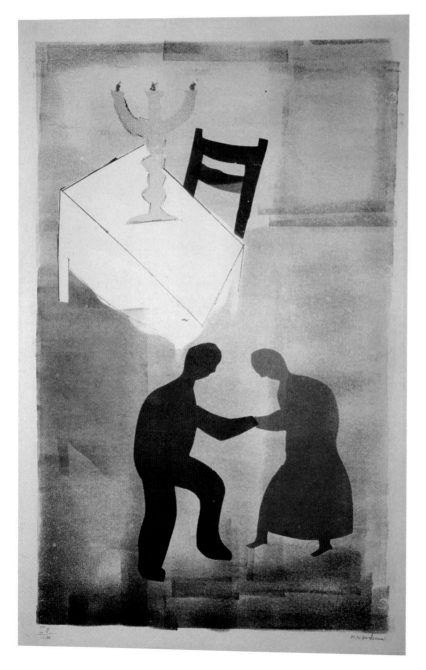

number 8, *"De Sabbat der eenvoudingen"*
uit het verhaal: "Het Drievoudig lachen" ("The
Sabbath of the Humble" from the story
"The Threefold Laugh")

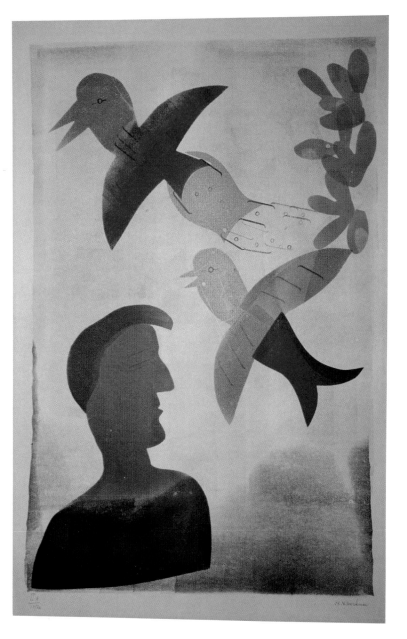

number 9, *"De taal der vogelen" uit het verhaal:*
"De taal der vogelen" ("The Language of the
Birds" from the story "The Language of the
Birds")

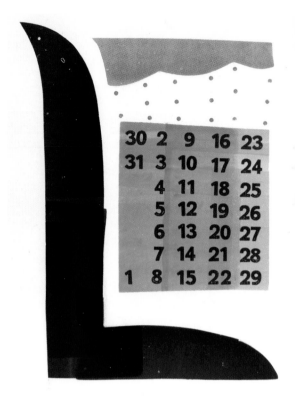

100 *Kalender 1944* (1944 Calendar)
1943, 32 × 24·5 cm (12¹₂ × 9⁵₈ in)
12 sheets

Made with stencils and type, this calendar
exudes optimism even in the darkest of
times. Werkman would print one more
calendar for 1945.

January [TOP LEFT]
February [BOTTOM LEFT]
March [TOP CENTRE]
April [BOTTOM CENTRE]
May [TOP RIGHT]
June [BOTTOM RIGHT]

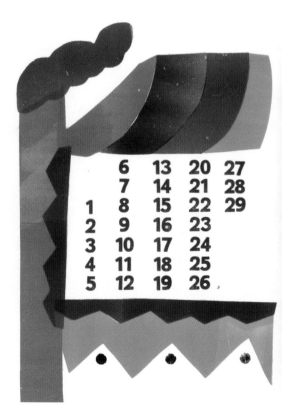

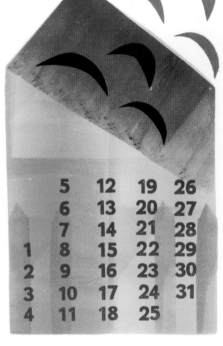

	5	12	19	26
	6	13	20	27
	7	14	21	28
1	8	15	22	29
2	9	16	23	30
3	10	17	24	31
4	11	18	25	

	7	1	21	28
1	8	1	22	29
2	9	1	23	30
3	10	17	24	31
4	11	18	25	
5	12	19	26	
6	13	20	27	

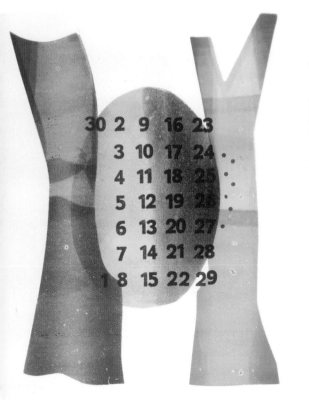

30	2	9	16	23
	3	10	17	24
	4	11	18	25
	5	12	19	2
	6	13	20	27
	7	14	21	28
1	8	15	22	29

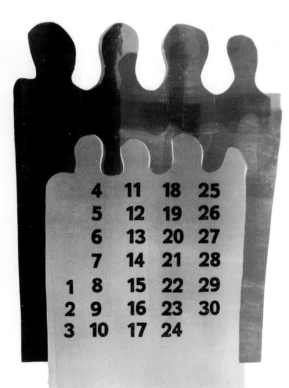

	4	11	18	25
	5	12	19	26
	6	13	20	27
	7	14	21	28
1	8	15	22	29
2	9	16	23	30
3	10	17	24	

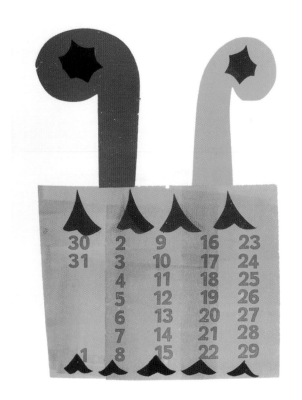

30	2	9	16	23
31	3	10	17	24
	4	11	18	25
	5	12	19	26
	6	13	20	27
	7	14	21	28
1	8	15	22	29

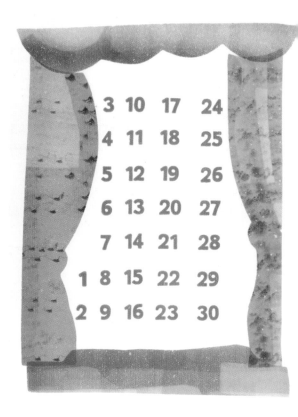

3	10	17	24
4	11	18	25
5	12	19	26
6	13	20	27
7	14	21	28
1 8	15	22	29
2 9	16	23	30

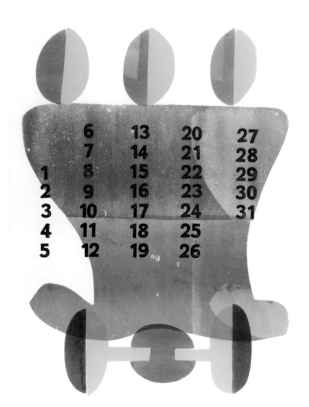

	6	13	20	27
	7	14	21	28
1	8	15	22	29
2	9	16	23	30
3	10	17	24	31
4	11	18	25	
5	12	19	26	

1	15	29
2	16	30
3	17	31
4	18	
5	19	
6	20	
7	21	
8	22	
9	23	
10	24	
11	25	
12	26	
13	27	
14	28	

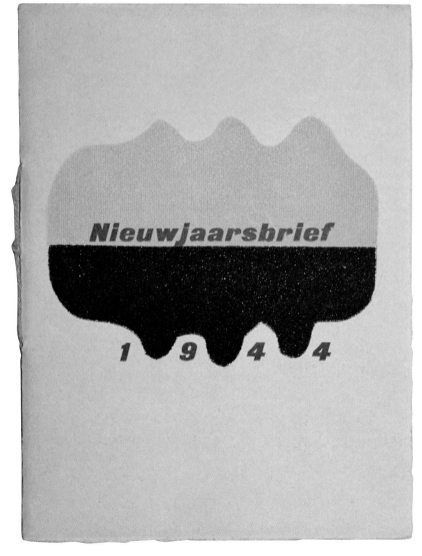

Nieuwjaarsbrief 1944
(New Year's Letter 1944)
Booklet
Publisher – De Blauwe Schuit
Text & poem – F.R.A. Henkels
De Blauwe Schuit 32
December 1943–January 1944
23 × 17·5 cm (9 × 6⁷⁄₈ in)
24 pages inc. front & back, 30 copies

De houtdiefstal (The Theft of the Wood)
Booklet
Publisher – De Blauwe Schuit
Poem – S. Vestdijk
Text & poem – F.R.A. Henkels
De Blauwe Schuit 34, 4 March 1944
30 × 21·5 cm (11⁷₈ × 8¹₂ in)
8 pages inc. front & back, 30 copies

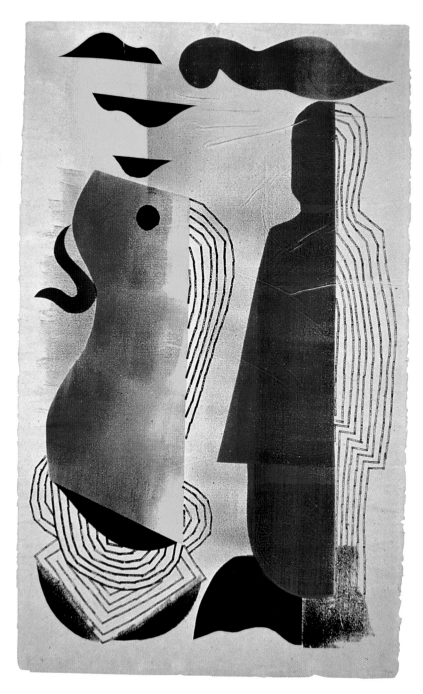

Kompositie met figuur
(Composition with Human Figure)
"Druksel" print
1944, 69·9×42·8cm (27$\frac{1}{2}$×16$\frac{7}{8}$in)
[LEFT]

In spite of adverse working conditions,
Werkman's production of druksels during
World War II was phenomenal. Even
though many druksels were destroyed as
the war drew to a close, 87 remain from
1941, 112 from 1942, 84 from 1943 and 128
from 1944.

Kompositie (Composition)
"Druksel" print
1944, 48·6×58·3cm (19×23in)
[OPPOSITE]

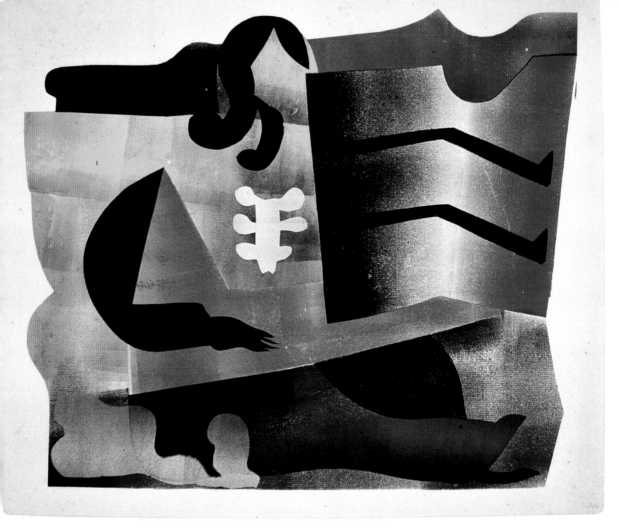

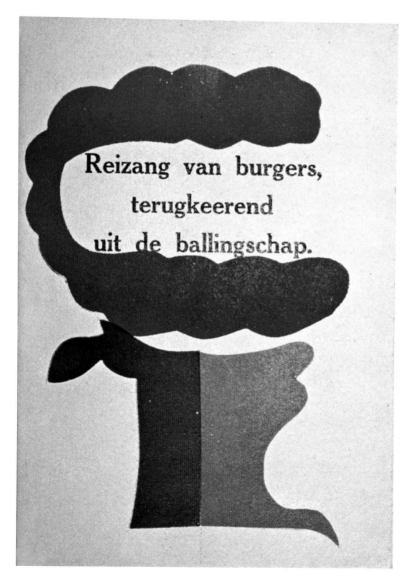

Reizang van burgers, terugkeerend uit de ballingschap.

Reizang van burgers (Round for Citizens)
Poem by P.C. Boutens
Publisher – De Blauwe Schuit
De Blauwe Schuit 40, June 1944
21·3 × 15·4 cm (8⅜ × 6 in)
Folded sheet, 90 copies

Enclosed in a stencilled composition, the text on the front confidently reads "Round for citizens returning from exile."

Terzinen van de mei (Terzinas of May)
Poem by J. B. Charles (W.H. Nagel)
De Bezige Bij (The Busy Bee), June 1944
30·5 × 21·1 cm (12 × 8⅜ in)
Folded sheet, 200 copies

In addition to his 40 publications for
De Blauwe Schuit, towards the end of the
war Werkman produced pieces for the
clandestine publishers – *De Bezige Bij*
(The Busy Bee) in Amsterdam and *In
Agris Occupatis* (In An Occupied Land)
in Groningen.

Notes

1. Alston W. Purvis, *Dutch Graphic Design: 1918–1945*, New York: Van Nostrand Reinhold, 1992.

2. Herbert Spencer, "H.N. Werkman, Printer-Painter", in *Typographica*, old series no. 11, 1955, p. 20.

3. Paul Schuitema, "Neue Typografie um 1930", in *Neue Grafik*, 1961.

4. Letter to F.R.A. Henkels, 4 August 1943, in Jan Martinet (ed.), *Brieven van H. N. Werkman, 1940–1945*, Uitgeverij, Amsterdam: De Arbeiderspers, 2nd ed., 1982 (first published 1968).

5. M.H. Werkman, *Memories of my Brother*, unpublished manuscript.

6. Letter to ds. F.R.A. Henkels, 12 May 1941, in Martinet (ed.), *Brieven van H. N. Werkman, 1940–1945*.

7. M.H. Werkman, *Memories of my Brother*.

8. Quoted in Adriaan Venema, De Ploeg, 1918–1930, Baarn: Het Wereldvenster, 1978, p. 74.

9. See Venema, *De Ploeg, 1918–1930*, p. 136.

10. M.H. Werkman, *Memories of my Brother*.

11. Letter to Paul Guermonprez, 22 May 1942, in Martinet (ed.), *Brieven van H. N. Werkman, 1940–1945*.

12. Letter to Michel Seuphor, January 1930, quoted in Hans van Straten, *Hendrik Nicolaas Werkman*, Amsterdam: Meulenhoff, 1980, p. 78.

13. Letter to Michel Seuphor, 19 November 1924, quoted in Venema, *De Ploeg, 1918–1930*, p. 162.

14. Ad Petersen, *De Ploeg*, 's-Gravenhage: Uitgeverij Bzztöh, 1982, p. 56.

15. Letter to ds. F.R.A. Henkels, 12 May 1941, in Martinet (ed.), *Brieven van H. N. Werkman, 1940–1945*.

16. Letter to Michel Seuphor, 8 October 1924, quoted in Van Straten, *Hendrik Nicolaas Werkman*, p. 33.

17. Quoted in P. and J. Boyens, *Expressionisme in Nederland, 1910–1930*, Zwolle/Laren, 1994, p. 70.

18. *The Next Call 1*, 6 October 1923, pp. 1–7.

19. Letter to ds. F.R.A. Henkels, 24 January 1941, in Martinet (ed.), *Brieven van H. N. Werkman, 1940–1945*.

20. Letter to ds. F.R.A. Henkels, 23 July 1941, in Martinet (ed.), *Brieven van H. N. Werkman, 1940–1945*.

21. Dick Dooijes, *Over typografie en grafische kunst*, Amsterdam: Lettergieterij en Machinehandel voorheen N. Tetterode, 1966, p. 72.

22. *The Next Call 1*, 6 October 1923, p. 3.

23. Letter to ds. F.R.A. Henkels, 14 February 1942, in Martinet (ed.), *Brieven van H. N. Werkman, 1940–1945*.

24. See Monica Straus, "Dutch Book Design: The Avant-Garde Tradition", *Fine Print*, October 1989, Vol. 15, No. 4, p. 177.

25. Theo van Doesburg, letter to H.N. Werkman, 2 July 1924, quoted in van Straten, *Hendrik Nicolaas Werkman*, p. 73.

26. Letter to Paul Guermonprez, 5 May 1941, in Martinet (ed.), *Brieven van H. N. Werkman, 1940–1945*.

27. *The Next Call 6*, October–November 1924, back cover.

28. *The Next Call 9*, November 1926, p. 2.

29. Johan van Zweden, "H.N. Werkman, De Groningse Drukker-Schilder" in Han Steenbruggen and Sjoukje Posthuma (eds.), *Hendrik N. Werkman*, a catalogue published on the occasion of the exhibition "Werkman", 9 November 1995 to 14 January 1996, Groningen: Groninger Museum, 1995, p. 28.

30. Hendrik de Vries and Dr. A.J. Zuithoff, *Werkman, Drukker-Schilder*, Amsterdam: Stedelijk Museum, 1945, p. 3.

31. Quoted in Venema, *De Ploeg 1918–1930*, p. 141.

32. Letter to ds. F.R.A. and Julia Henkels, 5 May 1943, in Martinet (ed.), *Brieven van H. N. Werkman, 1940–1945*.

33. M.H. Werkman, *Memories of my Brother*.

34. Letter to ds. F.R.A. Henkels, 24 January 1941, in Martinet (ed.), *Brieven van H. N. Werkman, 1940–1945*.

35. Letter to Paul Guermonprez, 25 September 1942, in Martinet (ed.), *Brieven van H. N. Werkman, 1940–1945*.

36. Letter to Michael Seuphor, 7 June 1927, quoted in Venema, *De Ploeg 1918–1930*, p. 199.

37. De Vries and Zuithoff, *Werkman, Drukker-Schilder*, p. 5.

38. Quoted in van Straten, *Hendrik Nicolaas Werkman*, p. 111.

39. *De Blauwe Schuit 1*, December 1940.

40. Graham Wood, "Werkman Call Resounds Still", in *Creative Review*, vol. 20, no. 11, November 2000, p. 98.

41. Jurrie Poot, "Werkman and the avant-garde" in Steenbruggen and Posthuma (eds.), *Hendrik N. Werkman*, p. 28.

42. Quoted in Henk van Os, *Hanson, job*, Groningen: Wolters-Noordhoff/Forsten, 1989, p. 62.

Selected Bibliography

blications by Werkman

eludium, Groningen:
.N. Werkman, 1938.

oclamatie, Groningen:
.N. Werkman, October
32.

oclamatie II, Groningen:
.N. Werkman, November
32.

Books and articles about Werkman

Beeren, W.A.L., The Next Call van H. N. Werkman, Groningen: Instituut voor Kunstgeschiedenis, 1978.

Blankenstein, B., "Werkman, H.N.", TéTé (Technisch Tijdschrift voor de Grafische Industrie), Nummer 6 en 7, eerste Jaargang, January-February 1946.

Bromberg, Paul (ed.), Werkman, Arnhem: Netherlands Informative Art Editions. S. Gouda Quint-D. Brouwer and Son, 1950.

Divendal, Joost, "Werkman en de druksels van het paradijs", De Waarheid, 4 March 1985.

_____, "Hendrik Nicolaas Werkman, Het Verlangen naar Paradijs", De Trouw, 25 January 1990.

Dooijes, Dick, Hendrik Werkman, Amsterdam: J.M. Meulenhoff, 1970.

Duister, Frans, "Druksels nit het paradijs", Het Parool, 5 October 1977.

Grieshaber, H.A.P., Hommage à Werkman, Stuttgart: Fritz Eggert;I New York: George Wittenborn, 1957/58.

Henkels, F.R.A, Werkman, Over de nagedachtenis van onzen vriend, privately published by Henkels, Heerenveen, 1945.

Henkels, F.R.A. and Martinet, Jan, H. N. Werkman, Chassidische Legenden, Groningen: Wolters-Noordhoff, Bouma's Boekhuis, 1982.

H.N. Werkman 1882–1945, Uit De Blauwe Schuit, Groningen: Wolters-Noordhoff bv, 1995 (first published 1965).

Martinet, Jan, "De Blauwe Schuit", Museumjournaal, serie 3, nr. 9-10, 1958.

_____, Hot Printing, Amsterdam: Stedelijk Museum, 1963.

_____, "H.N. Werkman", Typographische Monatsblätter, 3 March 1965.

_____, H.N. Werkman, en de Chassidische Legenden, Haarlem: J. H. Henkes Grafische Bedrijven, 1967.

_____, Hendrik Nicolaas Werkman, 1882-1945, Amsterdam: Stedelijk Museum, 1977.

_____, The Next Call, facsimile ed., Utrecht: Reflex, 1977.

_____ (ed.), Brieven van H. N. Werkman, 1940-1945. Amsterdam: Uitgeverij, De Arbeiderspers, 1982.

_____, De Schilder Hendrik Werkman, Groningen: Martinipers, 1982.

_____, Chassidische Legenden, Een Suite van H. N. Werkman, Groningen: Wolters-Noordhoff, Bouma's Boekhuis, 1985.

Miffler, Fridolin, Althaus, Pieter F. and Martinet, Jan, H. N. Werkman, London: Alec Tiranti, 1967.

Purvis, Alston W., Dutch Graphic Design, 1918-1945, Van Nostrand Reinhold: New York, December 1992.

_____, "Hendrik Nicolaas Werkman and The Next Call", Massachusetts College of Art Catalogue, 1994.

_____, "The Typographic Art of H. N. Werkman", Print, May/June 1995, pp. 72–80 and p. 126.

Redeker, Hans, "Chassidische Legenden van Hendrik Werkman Herdrukt",

De Telegraaf, 20 December 1985.

Sandberg, Willem, "Hendrik Nicolaas Werkman. 1882-1945," Harvard Library Bulletin, Vol. XVIII, No. 4, October 1970.

Sandberg, Willem and Billeter, Erika, H. N. Werkman, Zürich: Kunstgewerbemuseum, 1966.

Schmalenbach, Werner, Hendrik Nicolaas Werkman, Hanover: Kestner-Gesellschaft, 1956.

Spencer, Herbert, The Penrose Annual, A Review of the Graphic Arts, London: Percy Lund, Humphries & Co. Ltd, 1964.

_____, Pioneers of Modern Typography, Cambridge, MA: The MIT Press, 1983.

_____, The Liberated Page, San Francisco: Bedford Press, 1987.

Steenbruggen, Han, Drijvers, Han and Siersema, Dick (eds.), De Ploeg, 1 on 1, 15 authors about 15 painters, Groningen: 1998.

Straten, Hans van, Hendrik Nicolaas Werkman, Amsterdam: Meulenhoff, 1980.

Vries, Hendrik de and Zuithoff, Dr. A.J., Werkman, Drukker-Schilder, Amsterdam: Stedelijk Museum, 1945.

Werkman, Fie, Herinneringen aan mijn vader Hendrik Nicolaas Werkman, Groningen: Wolters-Noordhoff/Forsten, 1987.

Werkman, H.N., 1882-1945, catalogue 292, Amsterdam: Stedelijk Museum, 1962.

Zweden, Johan van, "H.N. Werkman, De Groningse Drukker-Schilder", Apollo, I, December 1945, pp. 23–31.

Books and articles containing reference to Werkman

Andel, Jaroslav, Avant-Garde Page Design, 1900-1950, New York: Delano Greenidge Editions, 2002.

Blokker, Jan, De Wondren Werden Woord en Dreven Verder, Honderd Jaar Informatie in Nederland 1889-1989, Amsterdam: J.A. Blokker, 1989.

Brattinga, Pieter, Influences on Dutch Graphic Design, 1900–1945, Amsterdam: Brattinga, 1987.

Broos, Kees and Paul Hefting, Grafische vormgeving in Nederland, Een Eeuw, Laren N.H.: V+K Publishers and Amsterdam/Antwerp: Uitgeverij L.J. Veen B.V., 1993.

Damase, Jacques, La Révolution Typographique, Genève: Motte, 1966.

Day, Kenneth (ed.), Book Typography, 1815-1965 in Europe and The United States of America, Chicago: University of Chicago Press, 1965.

de Jong, Dirk (ed.), Het Vrije Boek in Onvrije Tijd, Leiden: A.W. Sijthoff's Uitgeversmaatschappij, 1958.

Dooijes, Dick, Over typografie en grafische kunst, Amsterdam: Lettergieterij en Machinehandel voorheen N. Tetterode, 1966.

_____, Boektypografische Verkenningen, Amsterdam: De Buitenkant, 1986.

_____, Wegbereiders van de Moderne Boektypografie in Nederland, Amsterdam: De Buitenkant, 1988.

_____, Mijn leven met letters, Amsterdam: De Buitenkant, 1991.

Selected Bibliography and Credits

Dooijes, Dick and Pieter Brattinga, *A History of the Dutch Poster 1890-1960*, Amsterdam: Scheltema & Holkema, 1968.

Friedman, Mildred (ed.), *De Stijl, 1917–1931, Visions of Utopia*, New York: Abbeville Press, 1982.

Henkels, F.R.A., *Logboek van de Blauwe Schuit*, Amsterdam: A.A. Balkema, 1946.

Heuvell, Hans van den and Mulder, Gerard, *Het vrije woord, De illegale pers in Nederland 1940-1945*, 's-Gravenhage: SdU Uitgeverij, 1990.

Hofsteenge, Cees and Drijvers, Prof. Dr. H.J.W. (eds.), *De Ploeg, 1918–1941*, Groningen: De Hoogtijdagen. Bejamin & Partners, 1993.

Jaffé H.L.C, *Over utopie en werkelijkheid in de beeldende kunst. Verzamelde opstellen van (1915-1984)*, Amsterdam: Meulenhoff/Landshoff, 1986.

Jong, Dirk de, *Het Vrije Boek in Onvrije Tijd*, Leiden: A.W. Sijthoffs Uitgeversmaatschappij, 1958

Kuipers, Reinold, *Gerezen wit, Notities bij boekvormelijks en zo*, Amsterdam: Querido, 1990.

Kuitenbrouwer, Carel, "Graphic Holland, A Prominent Place", *Dutch Arts*, July 1989, p. 26.

Leeuw-Marcar, Ank (ed.), *Willem Sandberg, Portret van een Kunstenaar*, Amsterdam: Meulenhoff Nederland, 1981.

Mahlow, Dietrich (ed.), *Art and Writing (Schrift und Bild)*, Baden-Baden: Staatliche Kunsthalle, 1963.

Meggs, Philip B., *A History of Graphic Design*, New York: Van Nostrand Reinhold, 3rd ed., 1998.

Müller-Brockmann, Josef, *A History of Visual Communication*, Niederteufen: Verlag Arthur Niggli AG., 1971.

Os, H.W. van, *H. N. Werkman*, Groningen: Uitgeverij J. Niemeijer, 1965.

_____, *Wobbe Alkema en de Groninger Schilderkunst*, Groningen: Wolters-Noordhoff en Bounia's Boekhuis, 1978.

_____, *Job Hansen*, Groningen: Wolters-Noordhoff/Forsten, 1989.

Petersen, Ad, *De Ploeg*, 's-Gravenhage: Uitgeverij Bzztöh, 1982.

Prokopoff, Stephen S. and Marcel Franciscono, *The Modern Dutch Poster*, Urbana-Champaign: Krannert Art Museum; Cambridge, MA: MIT Press, 1987.

Purvis, Alston W., "Renewal and Upheaval, Dutch Design Between the Wars", *Print*, November/December 1991, pp. 38–49.

_____, "In Agris Occupatis, Dutch Design During the German Occupation", *Print*, July/August 1996, pp. 96–105.

Raassen-Kruimel, Emke, *Nederlandse affiches voor 1940*, Amsterdam: Stadsuitgeverij, 1991.

Schippers, K., *Holland Dada*, Amsterdam: Em. Querido's Uitgeverij, 1974.

Schuhmacher, Wilma, *Catalogue 220: In den Zoeten Inval: Nederlandse Literatuur en Drukkunst, 246 Collector's Items*, Amsterdam: Antiquariaat Schuhmacher, 1989.

Staal, Gert and Wolters, Hester (eds.), *Holland in Form. Dutch Design 1945-1987*, 's-Gravenhage: Stichting Holland in Vorm, 1987.

Steenbruggen, Han, *De Ploeg verzameld in het Groninger Museum*, Groningen: Groninger Museum, 1993.

Steenbruggen, Han and Sjoukje Posthuma (eds.), *Hendrik N. Werkman*, Groningen: Groninger Museum, 1995.

Stokvis, Willemijn (ed.), *De Doorbraak van de Moderne Kunst in Nederland*, Amsterdam: Meulenhoff/Landshoff, 1984.

Straus, Monica, "Dutch Book Design: The AvantGarde Tradition", *Fine Print*, Vol. 15, No. 4, October 1989.

Venema, Adriaan, "Vier vergeten kunstenaars", *NRC Handelsblad*, 15 April 1977.

_____, *De Ploeg, 1918-1930*, Baarn: Het Wereldvenster, 1978.

_____, *Nederlandse Schilders in Parijs 1900-1940*, Baarn: Het Wereldvenster, 1980.

Wiegers, Jan, *De Buitenlandse Reis*, unpublished manuscript, c. 1945.

Credits

The author and publisher would like to express their special thanks to Wilma Schuhmacher for her advice and encouragement, and to those in the Werkman Foundation for their support of the project.

SUNDAY

SUNDAY

MONDAY

TUESDAY

ion magazines
during the two
ars with their
of daring aviation
d heroic battles,
r popular reading.
nt cover of the
ion magazine
vil Aces depicts
era dogfight
two Sopwith
s and a German

SUNDAY

SUNDAY

MONDAY

TUESDAY

Elephant-headed G
the god of new beg
and the remover o,
obstacles, is perha
most popular god
India. Hindus rega
with affection and
him at the start of
new project, whe
cooking a feast or
an exam paper. H
placed at the entr
temples so that w
may commence w